Excellence in Reborn Artistry™

Where each and every Baby is a "One of A Kind" Original

Coloring Techniques using Genesis Heat Set Paints

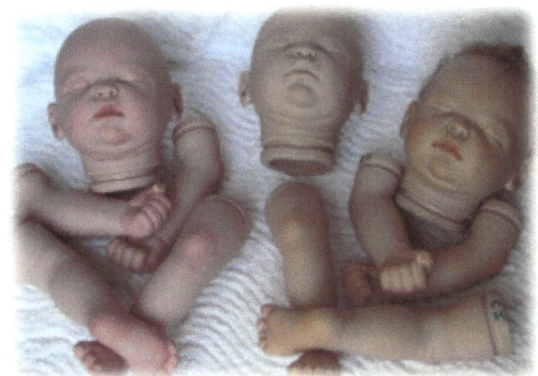 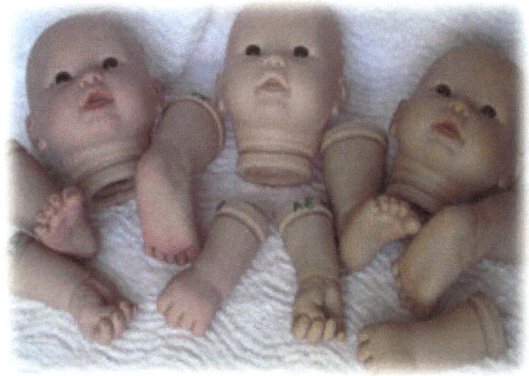

Part 1: Peaches & Creams

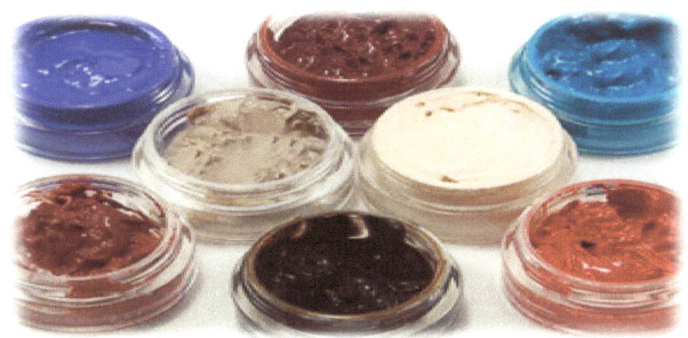

Jeannine Marie Holper

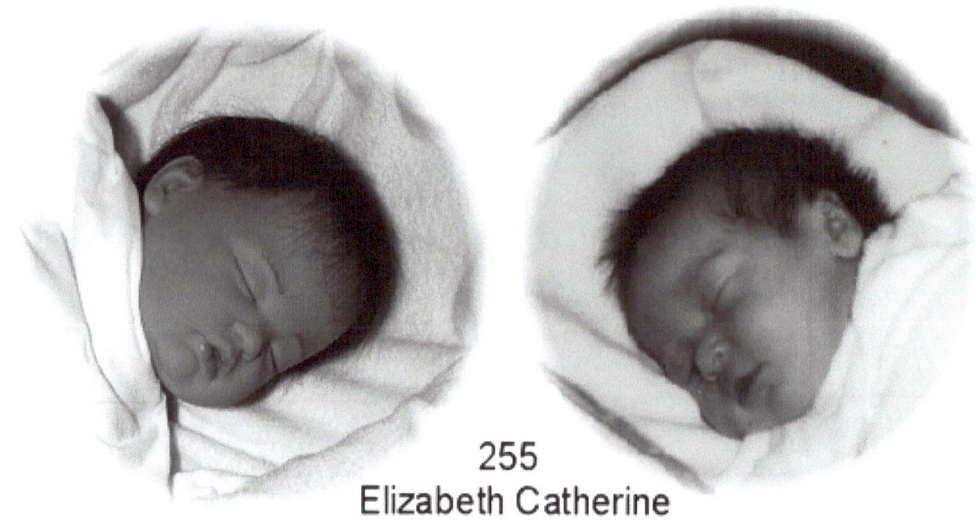

255
Elizabeth Catherine

www.RebornArtistry.com

The author and publisher have taken care in the preparation of this book, but make no expressed or implied warranty of any kind and assume no responsibility for errors or omissions. No liability is assumed for incidental or consequential damages in connection with or arising out of the use of the information or instructions contained herein.

Document Version 2007 – August-December

Copyright © 2007-2008 Jeannine M. Holper

All rights reserved. No part of this publication may be reproduced, stored in a retrieval system, or transmitted in any form, or by any means, electronic, mechanical, photocopying, recording or otherwise, without the prior consent of the publisher and author. Published and / or Printed in the United States of America.

ISBN 978-0-6151-8073-1

Released January 2008

CONTENTS

- **Introduction**
- **Supplies**
 - Newborn Kits & Reborn Doll Kits Basic Supplies
 - Internal Wash – Base Skin Tone
 - Veining
- **Base Skin Tones**
 - Techniques for Light to Medium & Darker Complexions
 - 19 inch Ming - Asian / light skin tones
 - 17 inch Zoe - Caucasian / light skin tones
 - 19 inch Starling - African American skin tones
 - Using the Color Wheel for Corrections
- **Peaches and Cream Complexion**
 - Blushing Basics
 - with Genesis Heat Set Paints
- **Finishing Touches**
 - **Accents & Body Art…**
 - Body Art for Eyes, Lashes and Brows, Accents for Lips
 - Body Accents for Creases and Wrinkles
 - Baby's Manicure
 - **Finishing Touches…**
 - Satin Sealants / UV Protection
 - Wonderful Baby Smells
 - Fun Options

Included throughout: Tips & Techniques

Secrist Doll Company is a manufacturer and provider of Reborn art supplies for Reborn artists and hobbyists. The painting supplies and dolls kits featured in this book have been obtained from the Secrist Doll Company. Although supplies, materials and doll kits may change from year to year, you can find their current line of products at www.Secristdolls.com.

Excellence in Reborn Artistry™

You, too, can transform a baby doll into a "Precious, True To Life Artist Baby"

Where each and every Baby is a "One of a Kind" Original

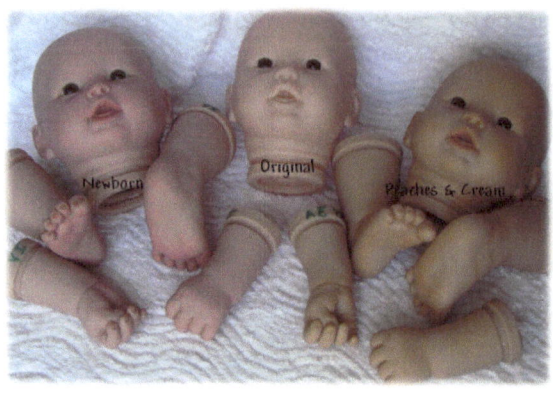

Thank you for taking the time to read this instructions book to *Learn To Paint: Coloring Techniques using Genesis Heat Set Paints GHSP.* This is a Part 1 of a 2 Part set in the Excellence in Reborn Artistry™ series of books to look into more details and specifics of the Reborn & Newborn Artistry techniques to create Collectible & Heirloom "One of a Kind" Dolls.

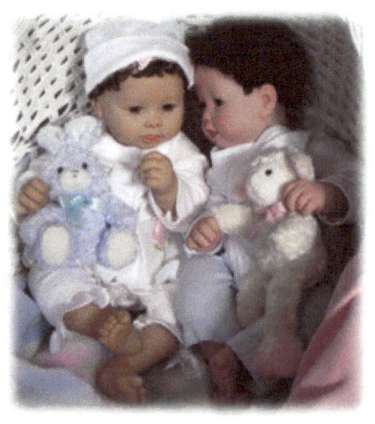

This **Learn to Paint** book will provide you a step by step process of transforming a Secrist™ Vinyl Doll Kit into a cherished collector doll. We will be using the Secrist™ Doll Kits for our samples: 19 inch Ming (Minueta) for our Asian reborn, 17 inch Zoe (Alyssa) for our Caucasian reborn, and 19 inch Starling (Tiesha) for our African American reborn. These three doll sculpts will be done in both Peaches and Creams Coloring Technique

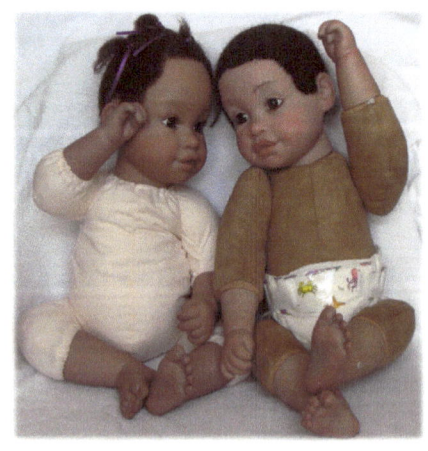

PatternsByJeannine™ Soft Body Patterns will be shown in addition to the Secrist Doll Kit bodies which come in their kits; so that you can see several samples of cuddly collectible newborn dolls.

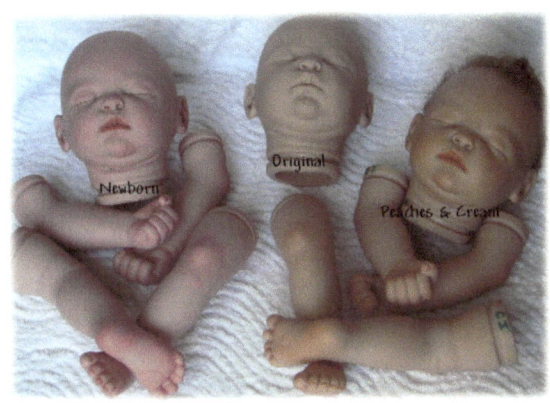

This instructions book will concentrate on the following Doll Kit areas: **The Base Skin Tone Internal Paint Technique** for your kits using Genesis Heat Set paints; **Peaches and Cream Complexion Blushing Techniques** using GHSP; In our **Finishing Touches** section we include Body Accents, Facial Accents (glistening eyes, lashes, & brows), veining and skin mottling samples, manicure options, baby smells, and moist lips. All our techniques will help to ensure that your baby is as perfect as possible and true to life.

For additional studies and content, we recommend that you also might consider the following books for more details on specific topics:

Excellence in Reborn Artistry™ series of books:

- Learn to Paint: Part 2: Newborn Layering Techniques
- Case Study #6 Realistic Hair Rooting Techniques
- Case Study #10: More on Mottling Techniques; Create your own OOAK mottling tools.

<div align="center">

Bring to life, your own

Custom Reborn Baby...

all they need is the time, love, and Dedication you can bring into their life.
Isn't it time for A Precious Heirloom Baby of your very own?

</div>

Please note: The statements above are generalized reborn artistry techniques to give you a feel for the efforts of the artist, and may not be included in each and every baby.

Reborn at your own risk. Each doll is different and these are just techniques, hints and suggestions, based on experience of the writer. We provide no warrantees or guarantees in your reborn activities.

Excellence in Reborn Artistry™
The Learn to Paint Series has three (3) books to choose from…

Excellence in Reborn Artistry™ Learn to Paint Part 1: Peaches and Creams
Features Myesha(Starling), Minueta(Ming), and Alyssa(Zoe)

Excellence in Reborn Artistry™ Learn to Paint Part 2: Newborn Skin Layering
Features Ty(Starling), Ming, and Allison(Zoe)

Excellence in Reborn Artistry™ Learn to Paint Master Collection
a.k.a. Collector's Edition at 120 pages & 300 pictures
Features Starling (Myesha & Ty), Ming (Minueta & Ming) Zoe (Alyssa & Allison), with a special guest star appearance by Taffy

Reborn Artists Supplies

Basic Supplies: Newborn & Reborn Artistry Tasks

Paint brushes. These brushes were hand-picked for use in reborning & newborning dolls. As an artist, I have found many of them them very useful and I'm sure they will become a great asset in your art work too. As you go through this 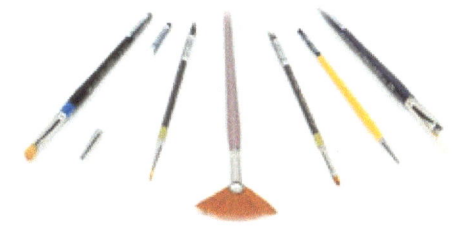 book we will remind you of the uses for many of these brushes to make your beautiful reborn baby dolls. Get these from secristdolls.com.

Make-up Sponges. Cosmetic foam wedges are wonderful for layering the base color of paints. These basic sponges can be used as a tool to apply your paints to the faces of your babies or use as an overall blending tool. With these smaller sponges you will be able to control the amount of blushing on the cheeks, apply the overall skin pigmentation on the initial layer(s) and even more.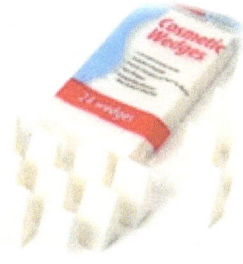

Cotton tipped applicators. In the art of reborning another great product is the cotton tipped swap applicators. They provide a basic application and touchup tool for the artist of all abilities. These applicators allow you access to small areas, as well as provide you a tool for clean up and touch up when paint gets into delicate hard-to-reach areas. The ball works well for clean up on larger areas while the point allows you to get into crevices and other tight places.

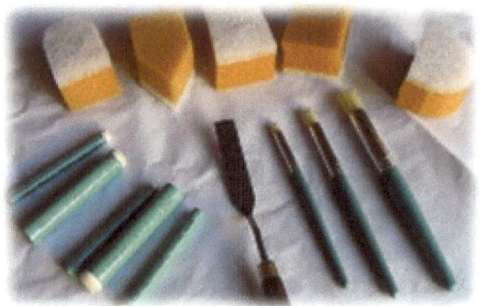

Stencil Brushes. I love the hardness of the stencil brush. I use them a lot for grabbing paint colors and mixing them together with thinner. They are also great for dry placing colors into crevices or smoothing out colors already within crevices.

Vinyl Sealants & UV Protectors. When there is a need to protect, use Genesis Heat Set Matte Varnish as your sealant. Please apply sparingly over two coats, as it is much better than one thick coat.

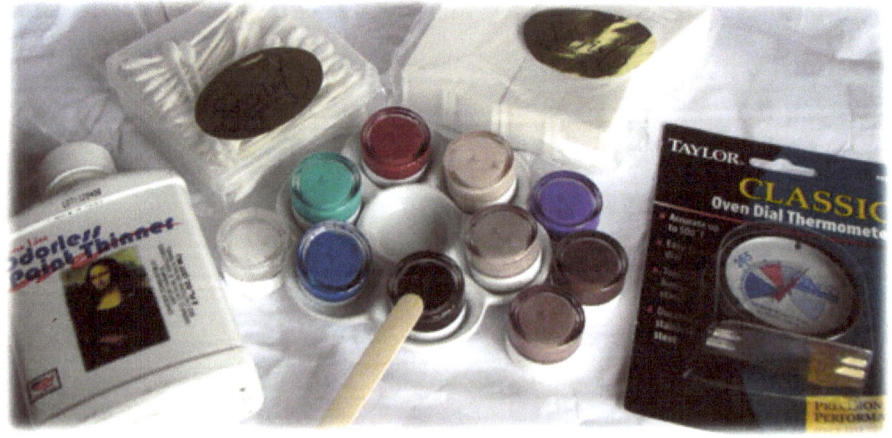

Disclaimer: This information is not an endorsement for any one particular tool or product. It only gives you options and processes that have been successful for many reborn artists. Please respect your tools and use them for Newborn & Reborn Artistry at your own risk.

You can obtain the **Genesis Paints Basic Paint Set** from www.secristdolls.com which comes with 9 different colors and a bottle of Odorless Thinner (100% Mineral spirits base). Here are our basic recommended colors to include…

1) Titanium White
2) Yellow
3) Flesh 04
4) Flesh 07, Flesh 08
5) Pyrrole Red, Crimson
6) Phthalo Blue, Ultramarine
7) Phthalo Green
8) Matte Finish

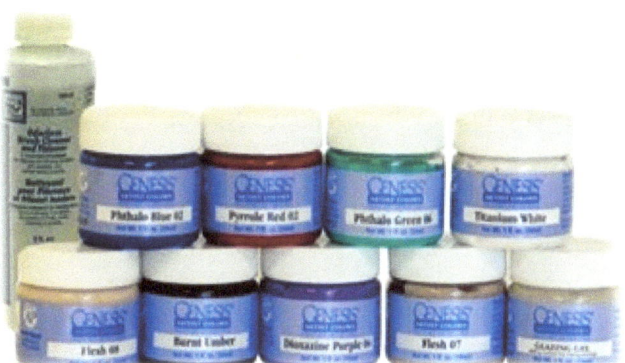

Mixing Trays. When mixing Genesis paints we recommend that artists avoid using plastic palettes. The strong bonding qualities of Genesis paints can react with certain plastic palettes and ruin the paint! These porcelain palettes have a kiln fired gloss coating that will last a life time and never wear out or react with your doll making paints. They are also very easy to clean after use. Larger porcelain containers for mixing can be picked up at most kitchen accessory stores.

Pre-Mixed Colors. If you have experienced the blush being too red or the baby looking like she has lipstick on! Secrist Dolls makes life easier with pre-mixed paints that are just the right color. This set contains all the essential colors, so if you don't want to spend time mixing, this is a great alternative.

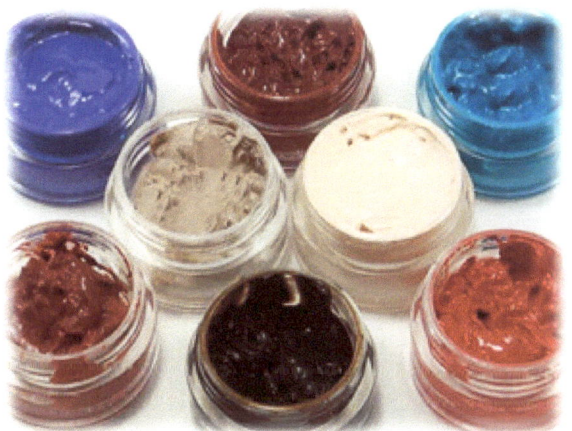

This set of paints is enough for 8 to 10 dolls depending on artist's usage and application. Except for Flesh 08, Periwinkle Blue and Blush, all other colors are used in

such small quantities that the petite amount will easily last for as many as 30 dolls when used as suggested. The Pre-Mixed Paint Set (each jar is labeled) includes:

Eyebrow Brown Paint, Periwinkle Blue Internal Wash Paint, Crease & Wrinkle Paint, Blush Paint, Lip Paint, Vein Paint, Flesh 07, & Flesh 08

Cure / Bake / Dry Time for Genesis Heat Set Paints. Between each layer of Genesis paints, you need to cure (or dry) your paint layer. To do this you can use your oven or Genesis Heat Set Gun. When using the oven, set to 265 degrees F, or 130 degrees C. Time the paint to dry in the over for at least 8 minutes, as the paint needs to reach this temperature in order to be permanently set. Then remove and allow your parts to cool to room temperature. Temperatures can affect the depth of the staining process; use caution as there are no guarantees.

OOAK Mottling Sponges for application of the newborn layering techniques. Makeup sponges, household sponges, craft sponges, sea sponges & more. All are great application tools for your painting mediums.

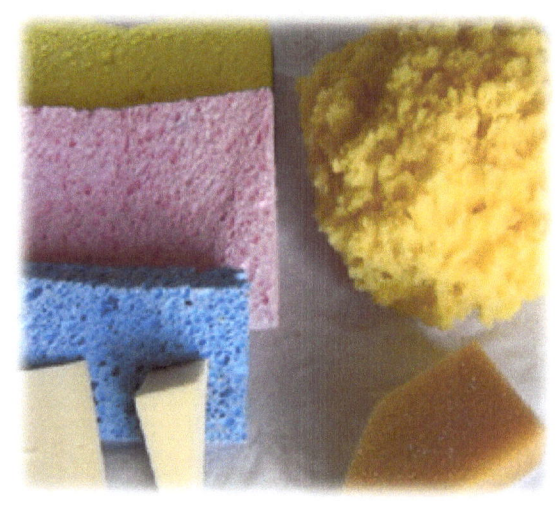

Paper Toweling & Sponges. For spills and quick wipe removal. A plastic picnic table cloth works well to protect your working area surface.

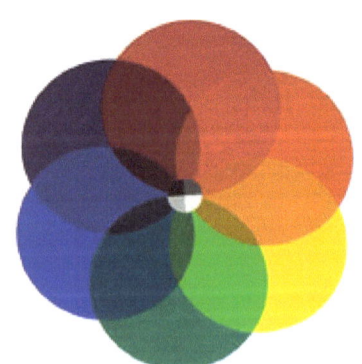

Color Wheels. Looking at the color wheels gives you a great opportunity to understand how the mixing of the primary colors creates new colors. It also provides an opportunity to look and see how might someone correct a color that has been created and make it better. Review the color wheels when you get to that section of the book on correcting colors.

For more color wheel samples, just search the internet for COLOR WHEELS.

Base Skin Tones for Vinyl Dolls

There is nothing that states you must change the skin tone of your vinyl kit. If you like the base color, then go ahead and start with your Peaches and Cream or Newborn Layering techniques. However, if you want or desire to enhance the shade of the vinyl color, here is one method used most by reborn artists.

Internal Color Application Method

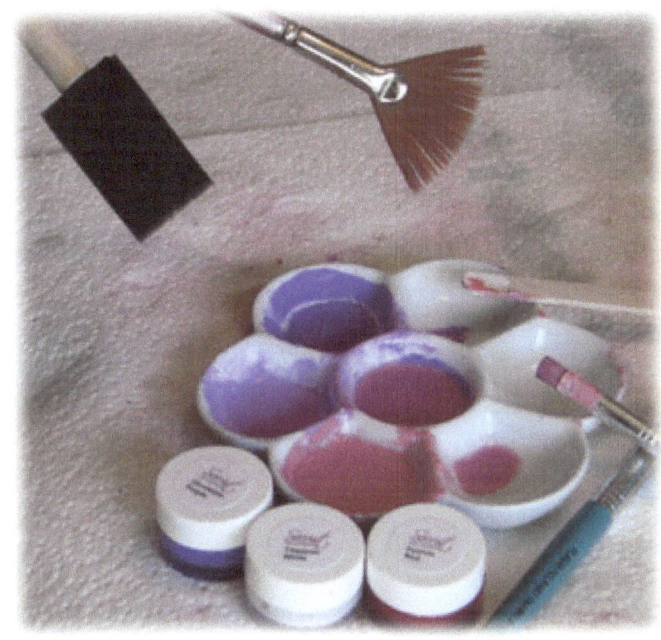

The light base skin coloring technique is usually done for Caucasian and light skin tone babies and use with vinyl that has a translucent quality. The thicker and harder the vinyl, the less effect any internal coloring will have on your reborn or newborn doll.

You will need to open up the ends of the head, arms and legs so that you can better work the internal coloring (sometimes called bathing) process.

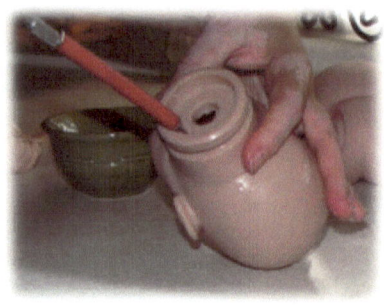

Using your exacto knife (or sharp knife) cut a circle cut at the ends of the limbs and head. Wash the inside of the vinyl with very warm soapy water and let dry completely. Once dry, wipe the insides with rubbing alcohol so that your painting medium will adhere the best it can.

When coloring, what you are trying to achieve is to transform your vinyl's original color to a living flesh tone color for the ethnicity of your choice. For light complexion, you normally would apply a <u>wine color</u>, or <u>light lavendar color</u> to achieve the correct tones as seen externally. This works for any light skin tone ethnicity.

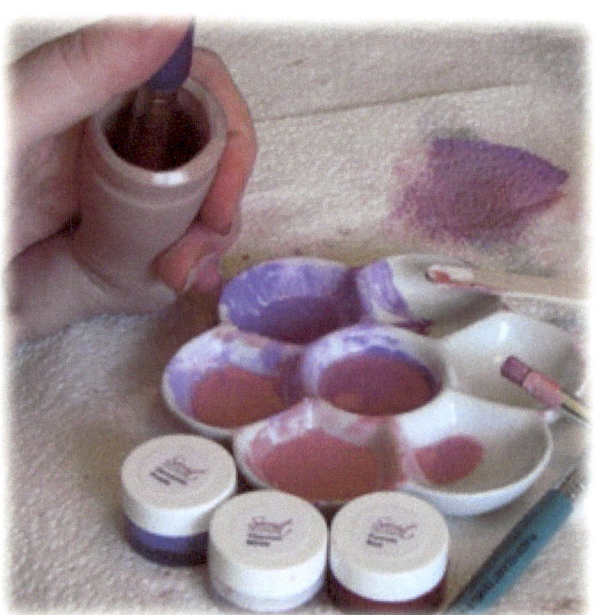

Using your fan brush or painting brush sponge, you just dip in the thinned out colors and apply to the inside of the vinyl. Then let dry via a "heat sest" session.

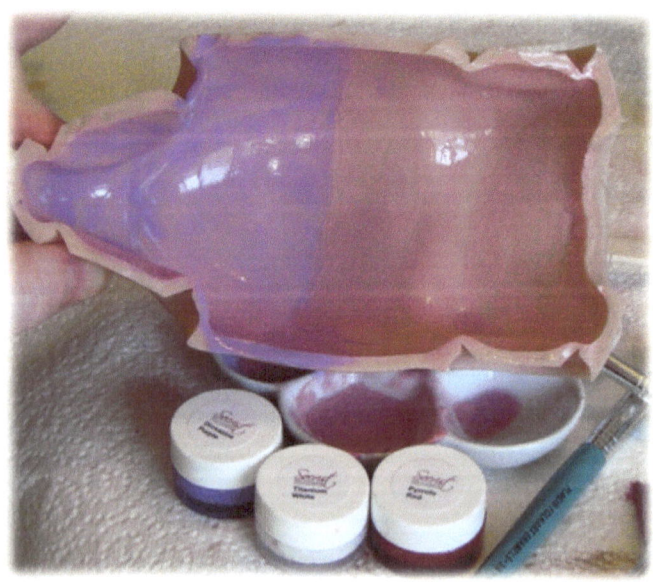

Below I've applied a mix of the Purple with Titanium white on the left. On the right I've applied a mix of Purple/Titanium white and a bit of red.

The mix is about 1 part genesis paint and 4 to 6 parts thinning medium. If you want a darker look externally, then allow the paint to be darker internally.

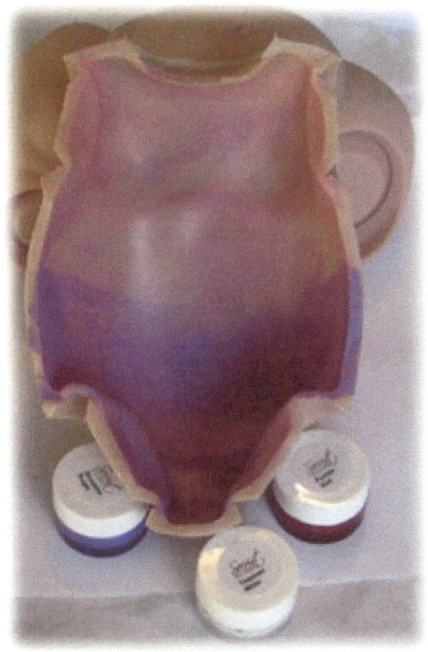 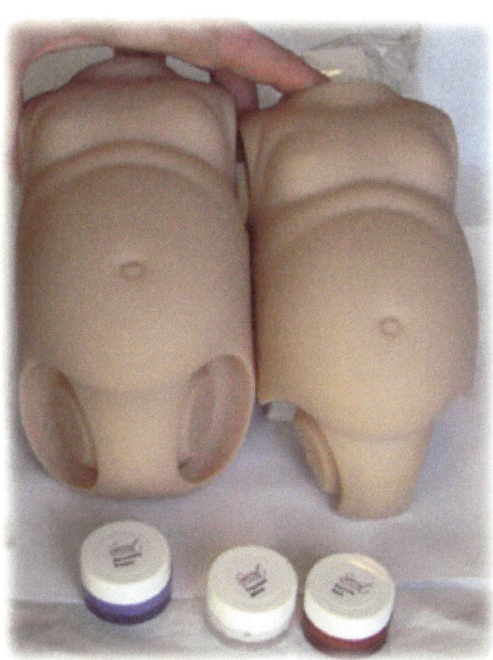

Shown at left is the inside of the tummy where you can see the cured or "heat set" paint. At right is the final product as compared to the original tummy.

Corrections to Skin Base using the Color Wheel Chart

If you want to correct/or eliminate a hue of color, you can use the color wheel chart; Select the opposite color in the color wheel, to determine which color shade to use to help tone out the color from being visible. For example, if you have a purple looking doll, then by looking at the chart at left, this would mean you would choose to use the orange, tan, or yellow shades to help tone out any purple, blue, or bluish hue from the stained or dyed vinyl.

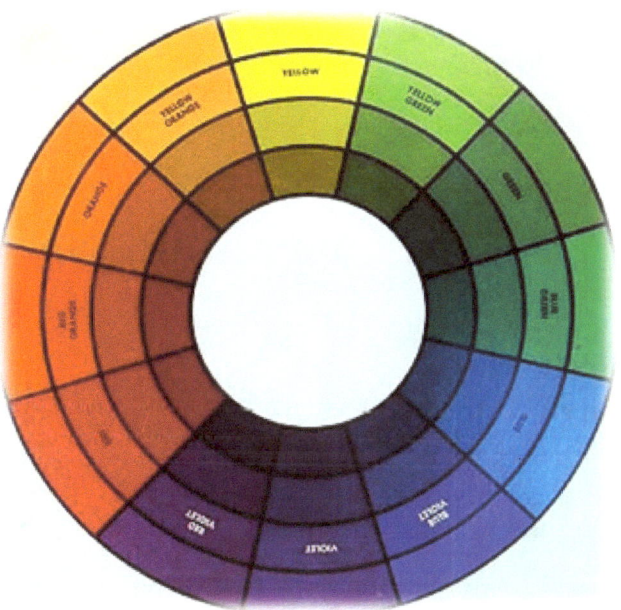

Veining & Mottling

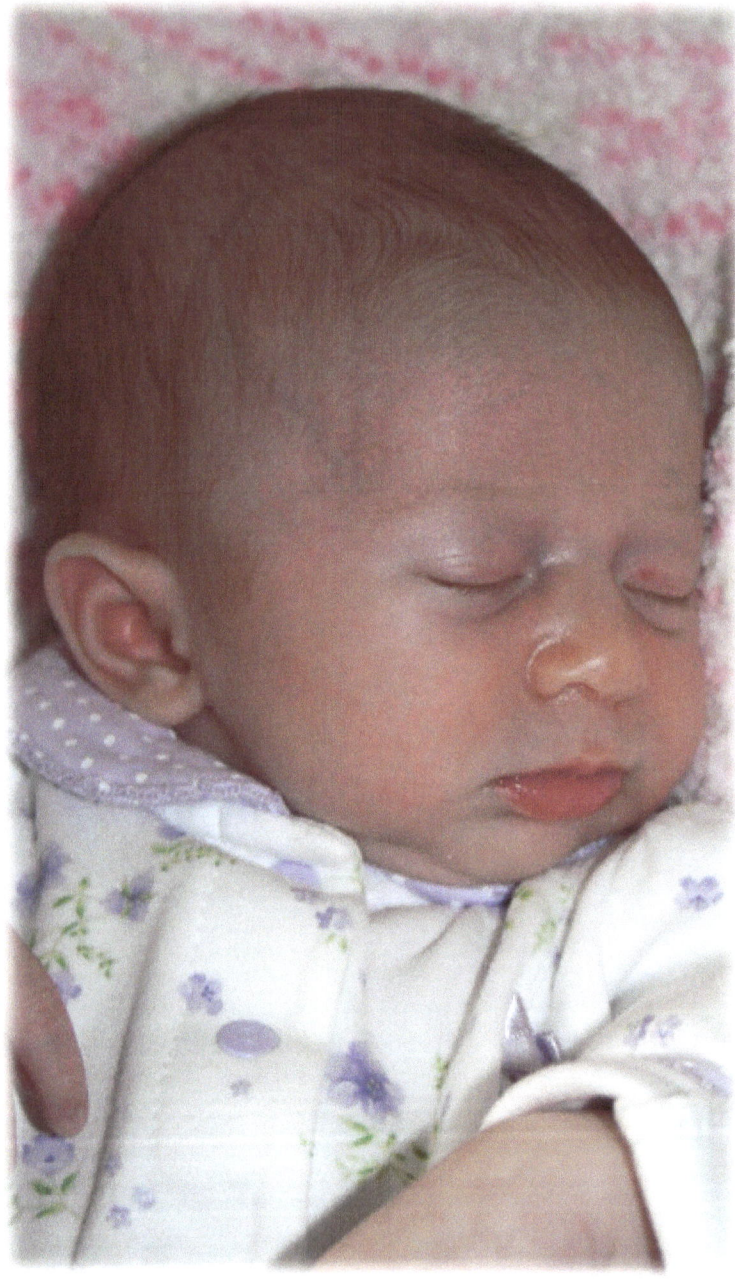

The Turquoise/Green/Marine Blue colors are typically used to apply the veins to the vinyl doll kit parts.

Thinned Burgundy colors work well for mottling arteries and capillaries.

Remember to blend/blush/pounce the vein strokes immediately upon application to the vinyl, as the some vinyl will absorb the paints ever-so-quickly.

Areas to consider for veining are: temples, forehead, neck, wrists, outside ankles, inside ankles, bottom and tops of feet, upper & outside hands. Search for baby pictures that show various veining possibilities.

Notice in the picture above her veining on the left of the forehead, bluish shading around her eyes, birthmark on the right eyelid and mottling effect on her hands.

For detailed information on Veining & Mottling, see *Excellence in Reborn Artistry™ Case Study #10 More on Mottling...* available at www.lulu.com/jeannine.

Veining

For the veining step of our Peaches and Cream complexion reborn, there is a wide variety of colors to choose from: Blue, Blue/Green, Turquiose, etc.

The secret is to use a very thin line when applying the colors to the vinyl. So use a thin liner brush or ultra thin edge to gather up the paint medium to apply to the vinyl surface. For the Genesis Heat Set Paints, I add in some thinner to a teeny tiny bit of paint, prior to applying the color; remove any excess color on your brush by dragging the brush across the paper toweling; and then finally apply the very thin veins.

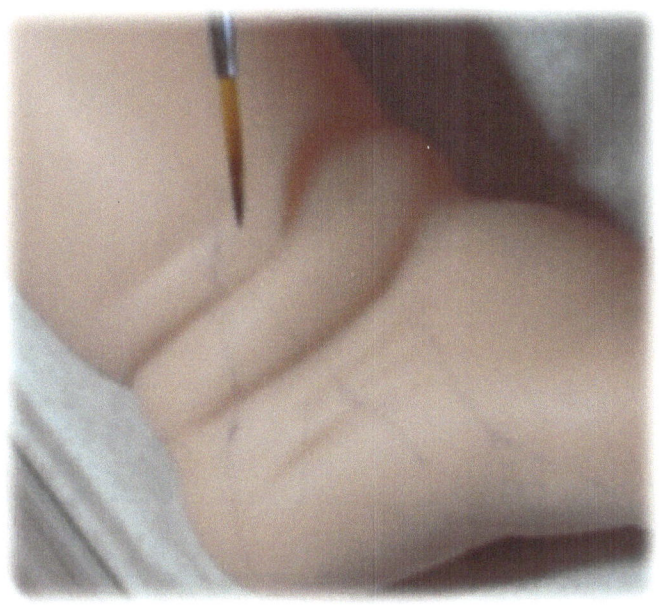

Let the colors sit there for a few minutes before using the application of a light dab of your make up sponge applicator over the area; be very careful not to drag or blend the applicator sponge. We just want to lightly remove any excess color for a more natural look.

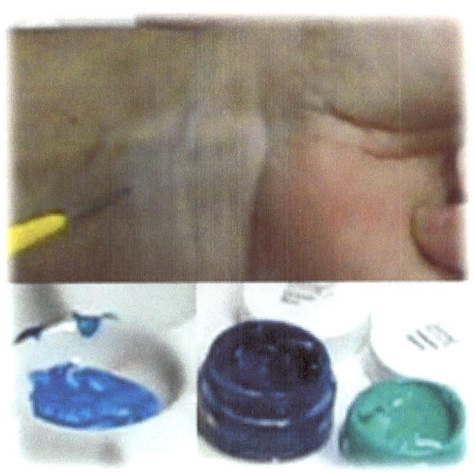

Shown at left is a picture of the two colors I mixed to create the veining color. If you look at my wrist to where I have pointed with the paint brush, you can see the veins are barely noticeable.

I always do my veining work before any of my skin coloring techniques.

Excellence in Reborn Artistry™

Section 2 – GHSP Coloring Techniques

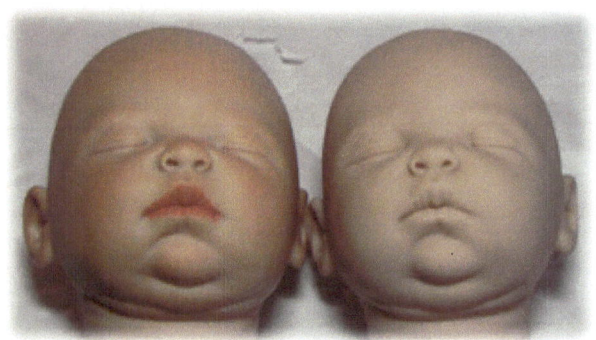 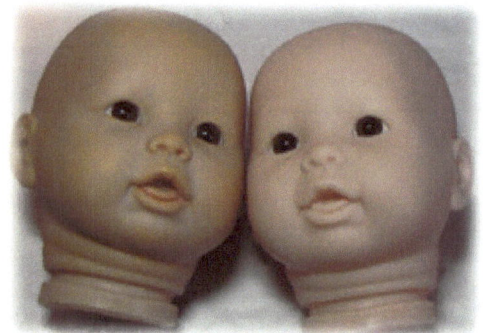

Peaches & Creams Complexions

 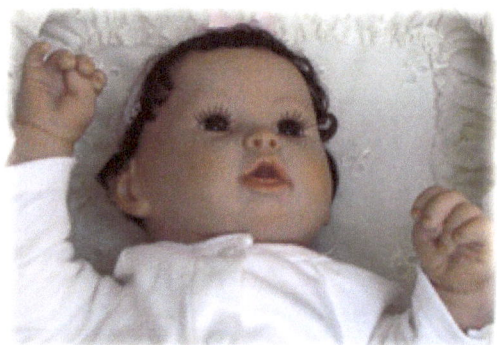

Peaches & Cream Complexion
The Basics

In this section we will look at several techniques to create the *Peaches and Cream* complexion on our Secrist™ Doll Kits using Genesis Heat Set Paints.

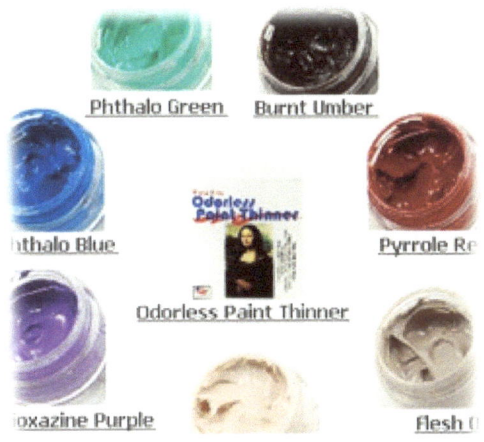

Disclaimer: This information is not an endorsement for any one particular tool or product. It only gives you options and processes that have been successful for many reborn artists. Please respect your tools and use them for Reborn Artistry on Secrist & other Dolls at your own risk.

Flesh 02	Quinacridone Crimson 01	Yellow Ochre
Flesh 03	Quinacridone Magenta 02	Yellow White 08
Flesh 04	Raw Sienna	Pyrrole Red 02
Flesh 05	Raw Umber	Phthalo Green
Flesh 06	Ultramarine Blue	Phthalo Blue
Flesh 07	Viridian Blue 01	Burnt Sienna
Flesh 08	White (Titanium)	Burnt Umber

Consider these GHSP colors when applying different skin tones.

CHALKS	BASE	DETAILS	BLUSHING	ACCENTS
Light	White/Yellow Flesh 07/08	Burnt Sienna	Flesh/ Tad Red mix	Burgundy
Asian	White/Yellow Ochre Flesh 08	Burnt Sienna	Flesh/ Tad Red mix	Dark Rose
Medium	White/Yellow Flesh 05	Burnt Umber	Flesh/ Tad Red mix	Crimson
Dark	White/Yellow Ochre Flesh 03 / Burdt Umber	Burnt Umber	Flesh/ Tad Red mix	Magenta

Preparation

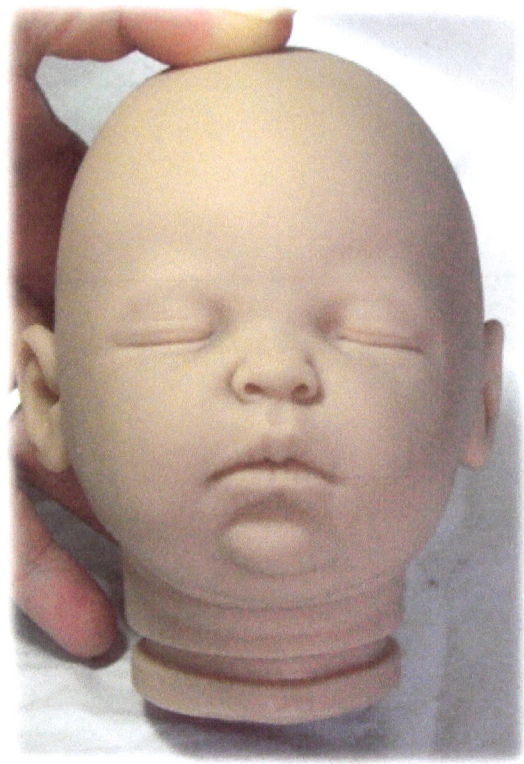

Prepare the vinyl and clean the surfaces of all the parts so that you have a clean and dry surface. You may clean with soap and water, and/or also with an alcohol based cleaner.

Make sure it is completely dry before starting your artwork for the best adhesion possible.

Then we want to prepare our genesis colors on our porcelain palette tray. The colors I have selected on my tray for this light skin reborn are:

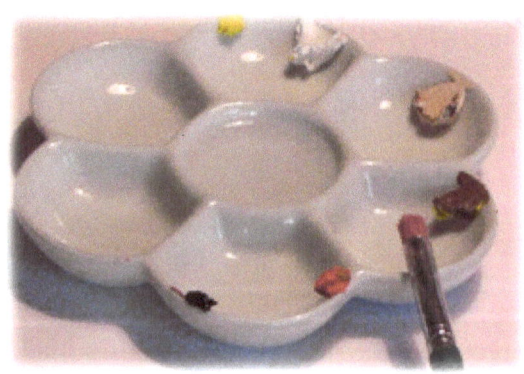

1. Titanium White
2. Yellow
3. Flesh 08
4. Flesh 04
5. Red
6. Blue

I'll be using a small stencil brush for mixing, a make-up applicator sponge and/or Fan brush for base color application and the liner brush for the detail work.

I use a soft blending cloth for blending the colors into the vinyl, but you can also use a makeup pad as well. And I have mineral spirits in my center tray shown above.

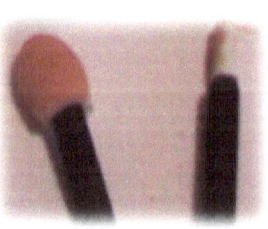

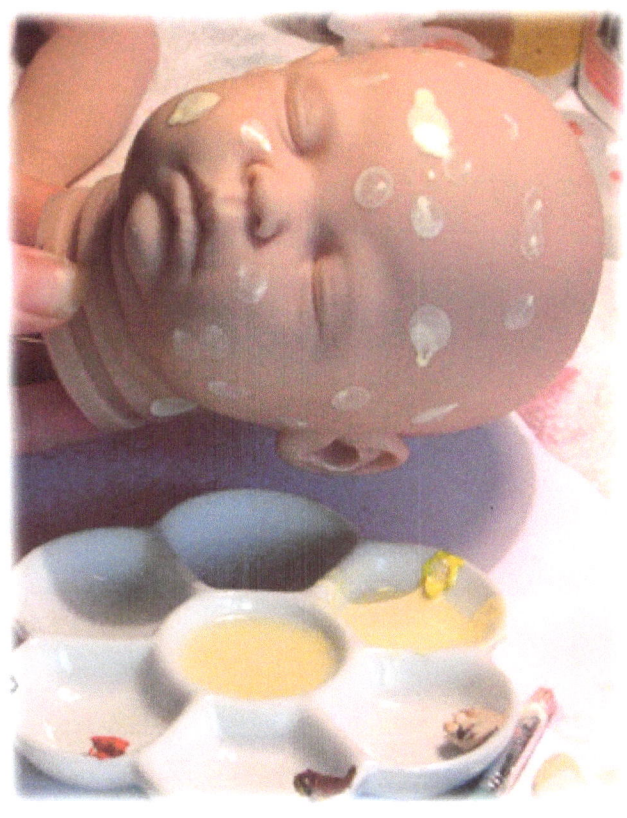

The application techniques that I use for Peaches and Cream complexion are basically the same for all the painting mediums: oils, stencil creams, chalks and pigment dyes. You will dab the thinned colors on the vinyl using a color applicator, and then blend them in with your makeup pad, blending cloth, stencil brushes, or whatever tool you feel most appropriate and/or comfortable.

On this Zoe kit sample, we are using the stencil brush to grab a mix of the white (3 parts) and yellow (1/2 part) to create a very soft color base. It is thinned with about 6 to 8 parts thinning medium.

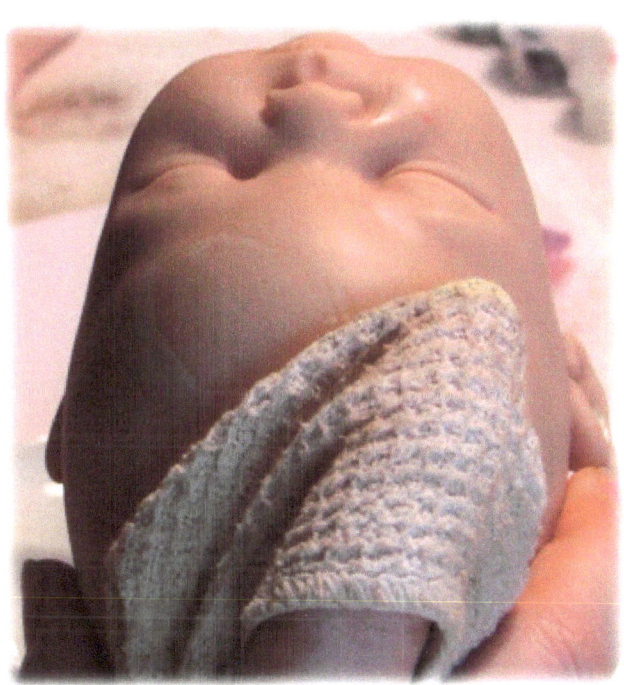

Then I take my blending cloth and wipe it all over the vinyl which gives it a slightly stained color. I just want to get a hint of this initial layer skin tone on the vinyl surface.

If you will be rooting the hair on these dolls, you have an option to also color the entire head, or at least an inch or two into the hair line.

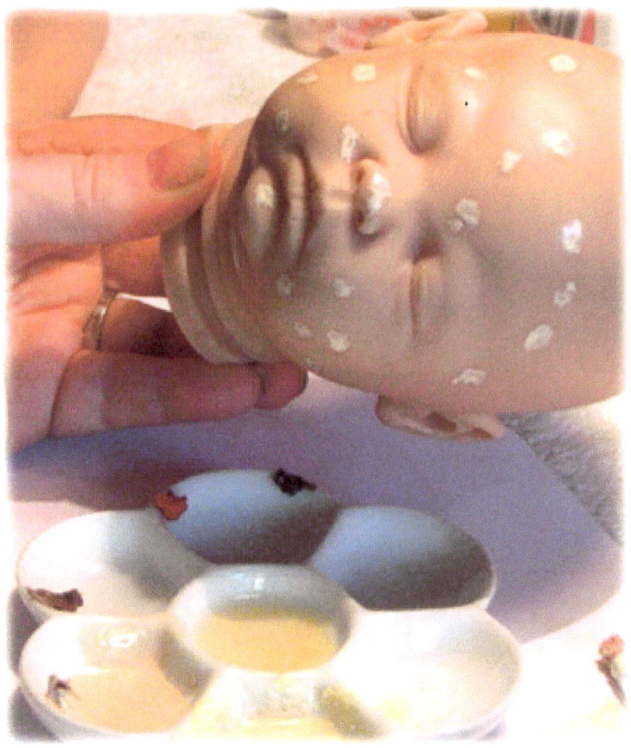

The next color I chose to add into our mixture is Flesh 08. I'll add in an equal part for this and mix in with additional thinning medium.

Using my makeup applicator tip, I dab into the color and blot directly all over the face.

Then rub it in again with my blending cloth.

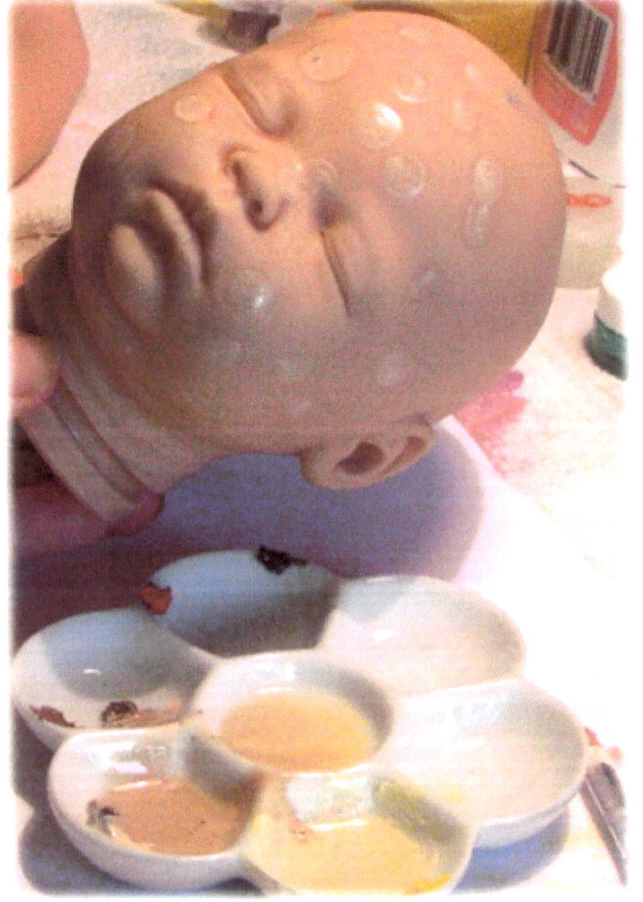

The next color I chose to add into our mixture is Flesh 04. I'll add in a 1/2 part for this and mix in with additional thinning medium.

Using my makeup applicator tip, I dab into the color and blot directly all over the face.

Then rub in again with my blending cloth.

I have not yet "heat set" the color in between the initial application and this blending effort.

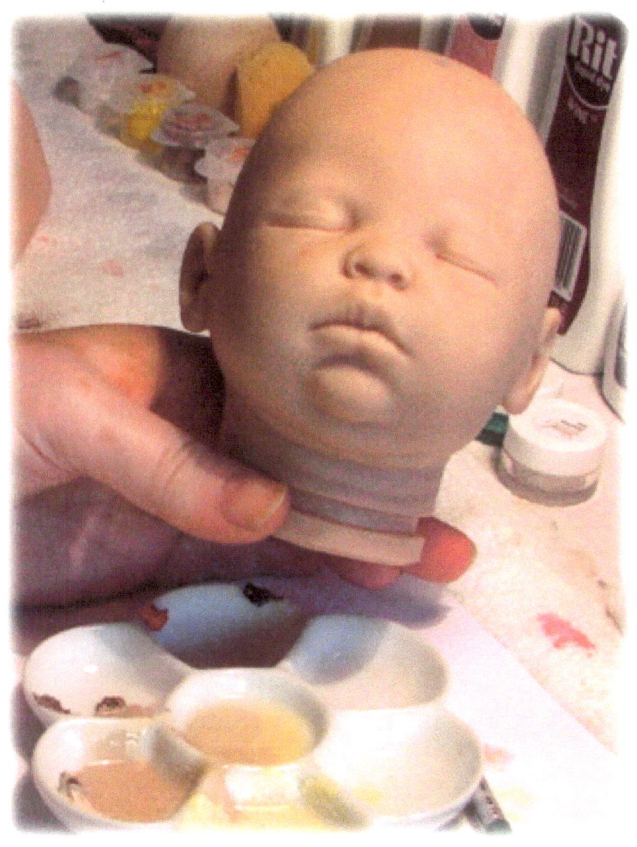

As you see in the picture, here is the Zoe doll kit head fully blended; it is now time for a "heat set" curing session in the oven to set the colors I've blended in prior to the continuation of the peaches and cream coloring layers.

To cure your GHSP you can use your oven to heat set the paint or you can use the Genesis Heat Set Gun. When using the oven, pre-set to 265 degrees F or 130 degrees C. (do not set in the vinyl parts in the oven during the pre-set time.) Set the vinyl doll parts to dry in the oven for at least 8 minutes, as the paint needs to reach the setting temperature in order to be permanently applied. Once the time has passed, pull the parts out of the oven and let the limbs cool naturally to room temperature.

Our next color is just a hint of red; as you can see at left, a small amount of red goes a long way to pink-en up our color base.

We will now start to blend in some of the accent points where we start to see the skin brighten up with living color. At right here I have lightly blushed on the ear with the makeup sponge applicator.

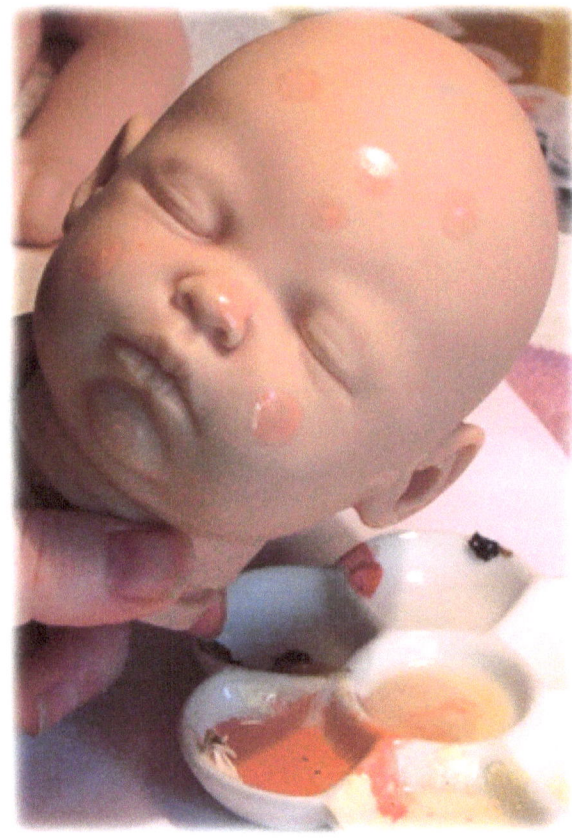

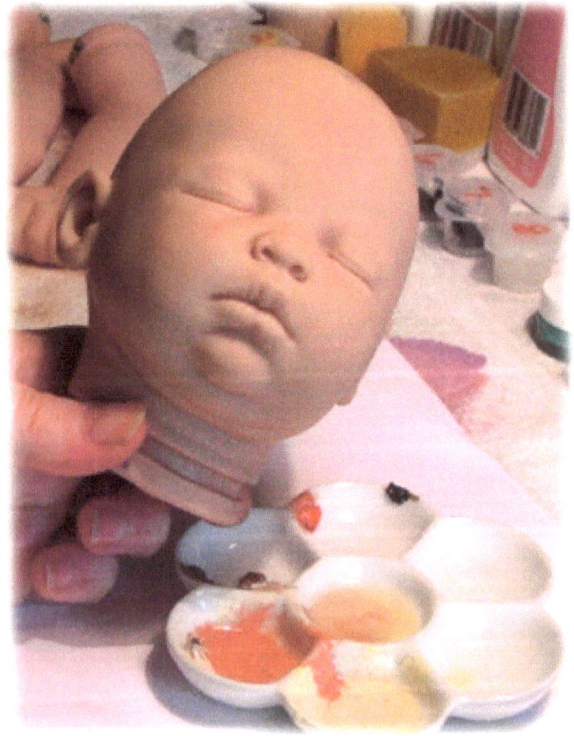

I'm starting to focus on dabbing the pink colors with the makeup sponge tip applicator; I'll use it to apply the color to the "T" forehead area, nose, cheeks, chin, and also the ears.

Once the color is applied to the vinyl, I return to my original blending cloth and blend in the colors across the face.

As an alternative to the blending cloth, you can also use the triangle makeup sponge for blending as well. If you find your colors look splotchy, then just add in a bit of thinning medium to the sponge in order to help the blending process along.

Continue to use the original blending cloth (or sponge, if you like) as it will help to blend in the base skin tone colors with the newly applied pinkish color, in this case a light version of apricot seems to be the shade.

You can add in more red

and do another blending session, or if you like what you have, it is time to "heat set" the paint.

But before we do that, let's do the limbs. This time let's use the Fan brush

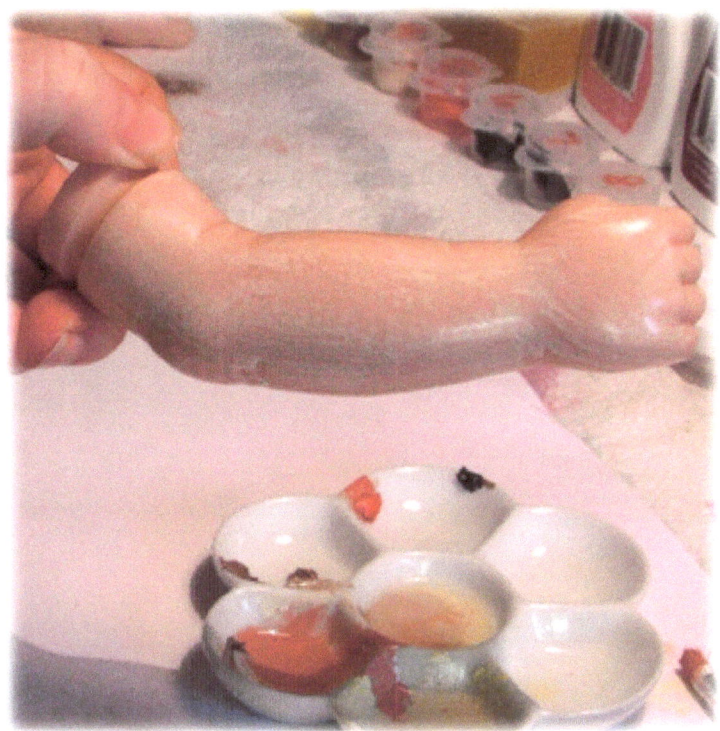

application and blending cloth method of color application.

I've already done the first layer on these limbs, so this picture at left shows you the flesh layer using the Fan brush for application. You just apply a thin layer all over with the fan brush; then use your blending cloth to blend in evenly all over the vinyl.

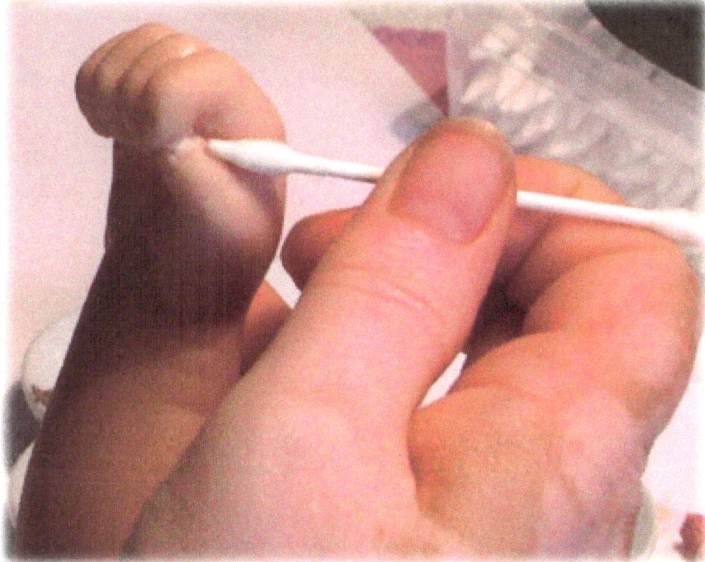

If you have any areas between the fingers or toes, where it looks like the paint is stuck, use your q-tip swabs to help remove the light paint colors.

You do not want to have light colored dried paint in the crevices of your fingers or toes; it can be very distracting to say the least ☺.

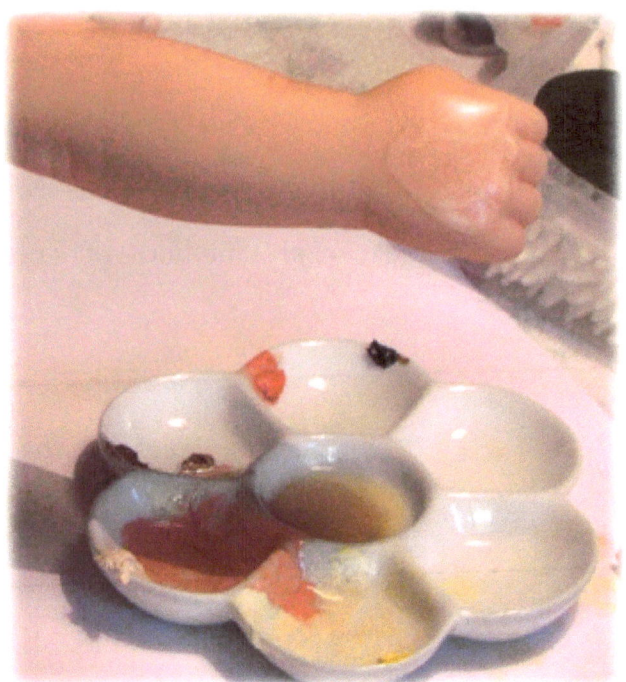

Once all the colors have been blended, follow this up by a "heat set" session in the oven with the head and other body parts.

On the hands and feet, I like to add the rose/apricot color to the back of the hands, back of the feet, under the feet, on top of the knees and at the elbow areas.

Some of you might want the pink color to be blended in all over. That's o.k. It's your reborn and you can color the doll any way you wish. You can even make the color a deeper pink by adding in a bit more red if you wish.

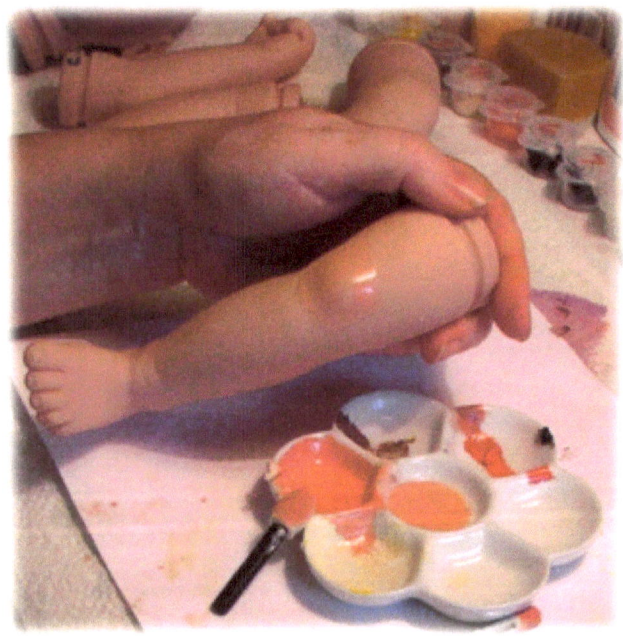

Do a "heat set" session after each color application, or you can deepen the colors and blend again before you go to do another bake.

You will find over time that you can

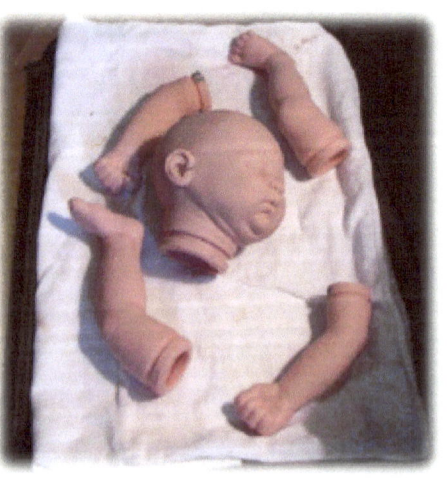

determine which layers can blend in, versus which needs to be "heat set" in order to deepen your desired color choices.

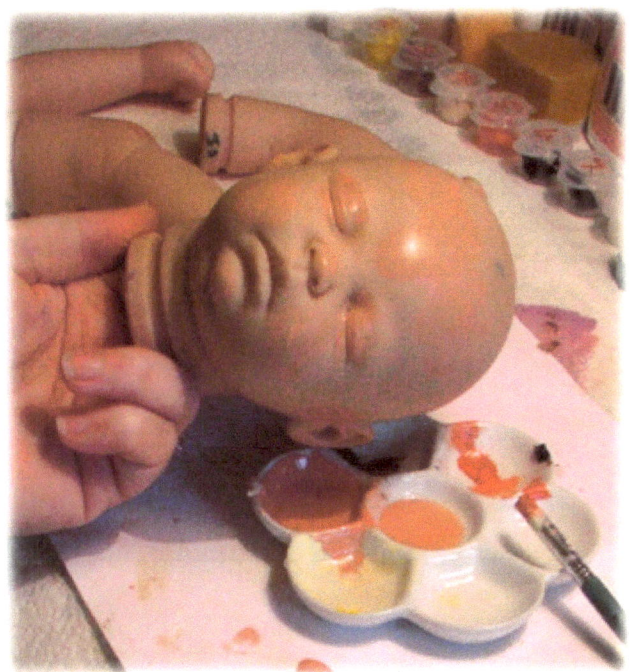

In this case, after the "heat set" was completed, I determined I want another layer of pink added into the color mix. I've added in just a hint more of the red and a little more thinner, and note this time besides doing the forehead, cheeks, nose, chin and ears, I've added in the eyes lids to give a little color depth for my sleeping beauty.

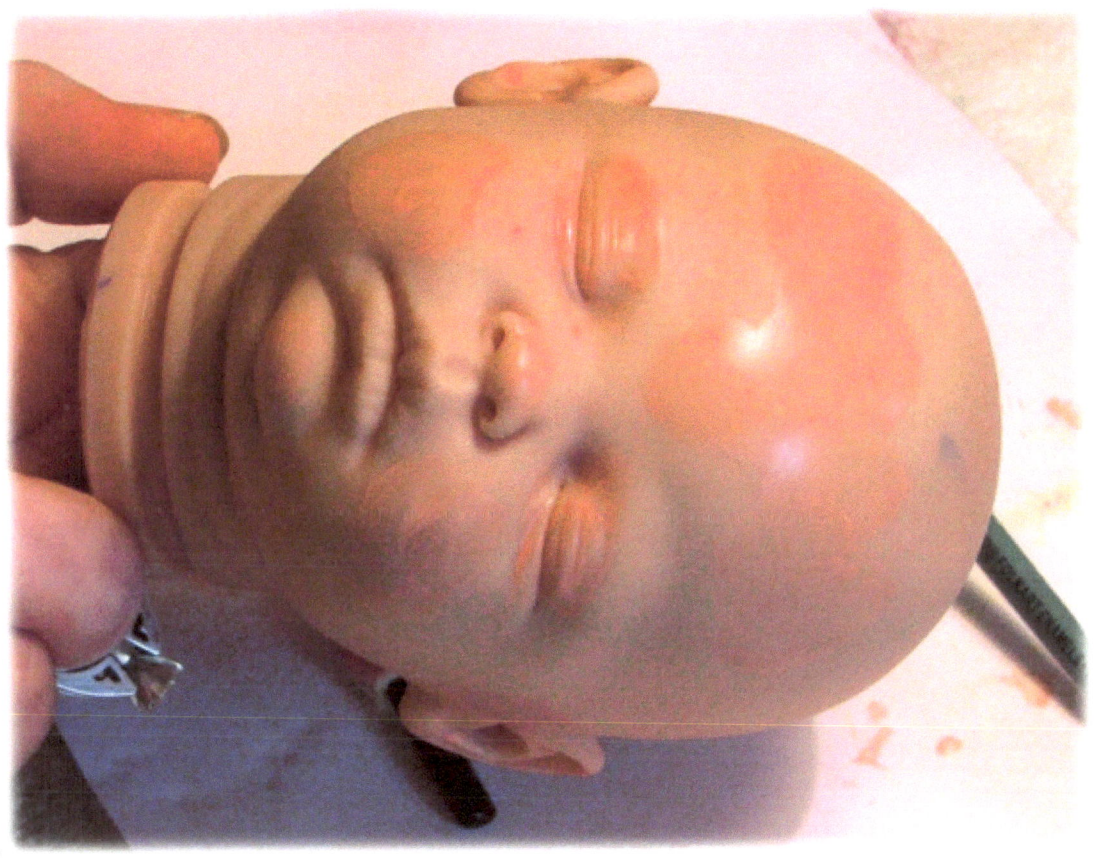

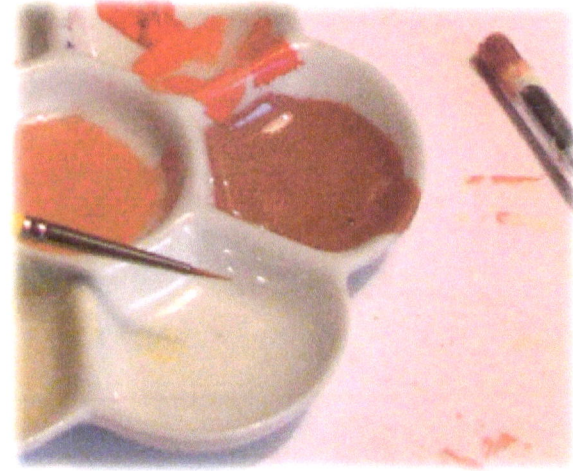

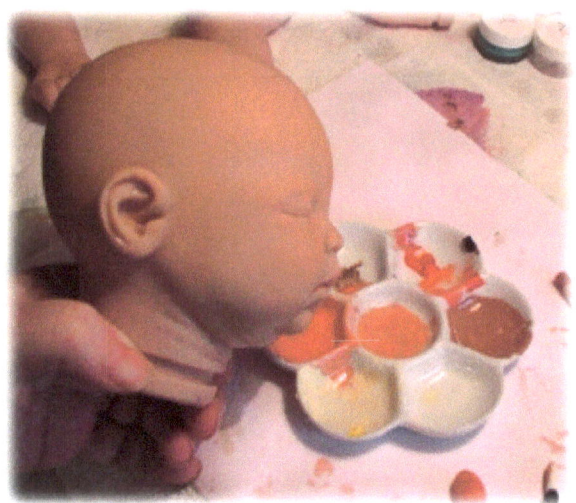

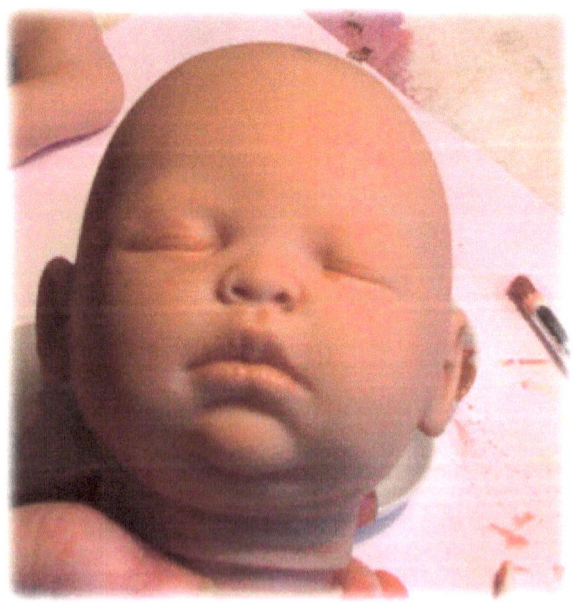

Once you complete your base colors, you will move into the detail work.

Here I've mixed in a bit of Flesh 04 into the pink mixture to create a brown ochre color. Any resulting medium or brown color will do in this step. I will use this to highlight the creases and crevices of the doll sculpt.

Since the doll I'm working on will be a light skin tone, I'm ready to go into detailing steps; however, if working on a medium to dark skin reborn, you may wish to blush in additional layers.

Using a thin liner brush, I pick up some of my brown coloring and apply a thin line of brown on all the creases of the eyes, around the nose, inside the nose, around and inside the ears, around the mouth and lip lines and under the chin. I will also line up the neck fold lines as well with this brown color mixture.

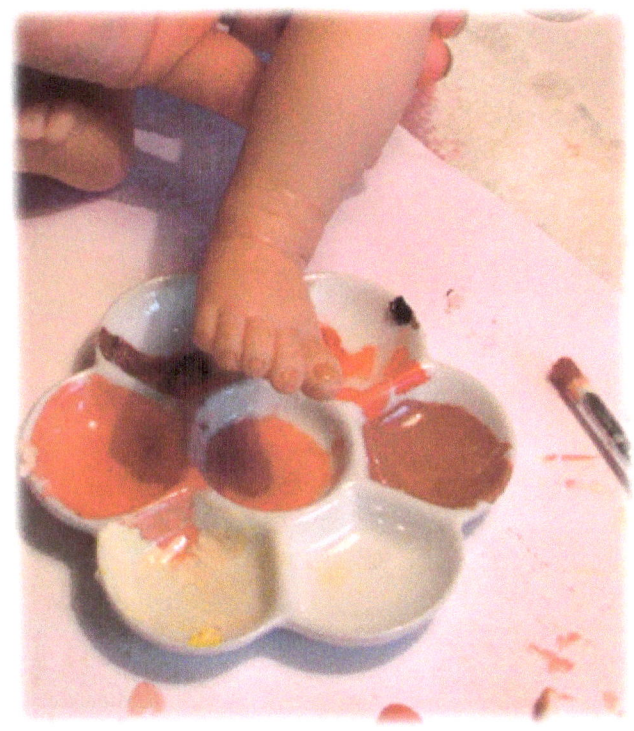

For detailing this newborn's limbs, we will concentrate on the nail beds, between the toes, the crevice marks at the knees and ankles.

I can apply the soft brown color details with a dry brush or a wet brush (dipped in thinning medium).

There may be areas you wish a finer line, so a wet brush would be more in order.

Or if you wish a more soft touch focus, then application with a dry brush would be better. Most times you will just have to try different techniques until you find the one best suited for the job.

Here and in Section 3, I have marked doll kits limbs with areas of emphasis noted; so just in case you can't see them well here, you will be able to see them better there.

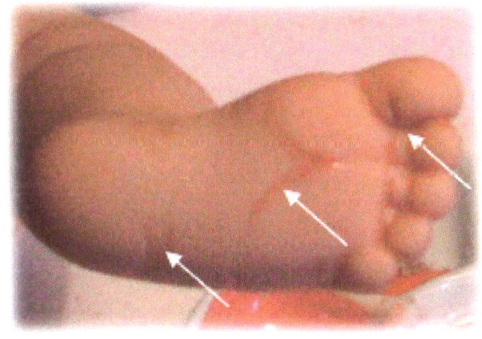
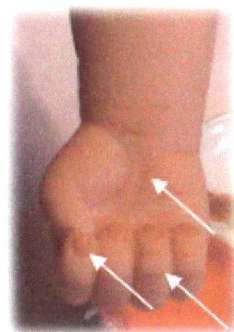
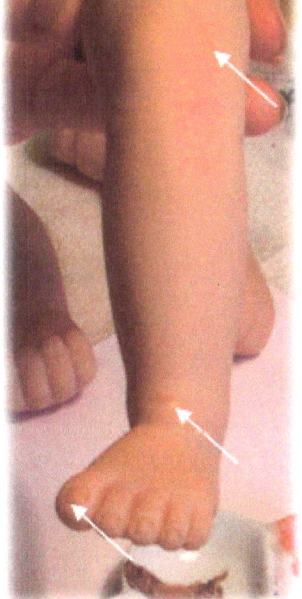

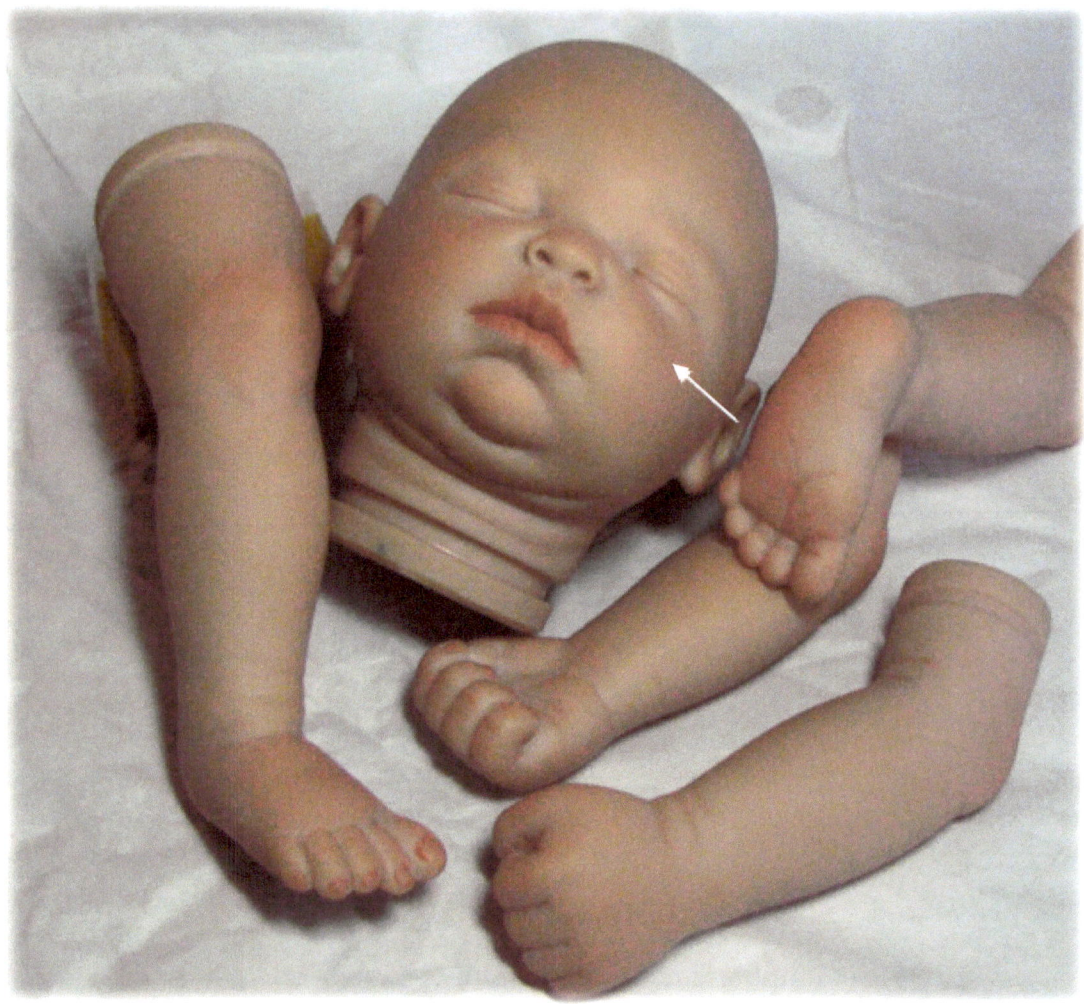

Sometimes I will do a bit of soft brown coloring (or the brown mixed with skin tone, or rose colors) on the front of the ears at the high cheek bone area, then I'll pick up my makeup sponge to blend and spread the color around the area.

It's o.k. to experiment with any colors you feel would be appropriate for your newborn. You don't have to just use the colors that have been presented.

There are many wonderful colors available, and every artist will need to create their own palette of colors to work with over time.

After I finish the soft brown detailing work, I come back for additional natural rose highlights in all the delicate areas.

Sometimes I may alternate using the triangle makeup sponge and blending cloth for general blending work, and I'll use a makeup sponge applicator tip for any smaller detailed areas, such as the ears.

The makeup sponge applicator, also known as chalk sponge tips can have rounded edges or pointy tips. Either one will work well in the detailed areas.

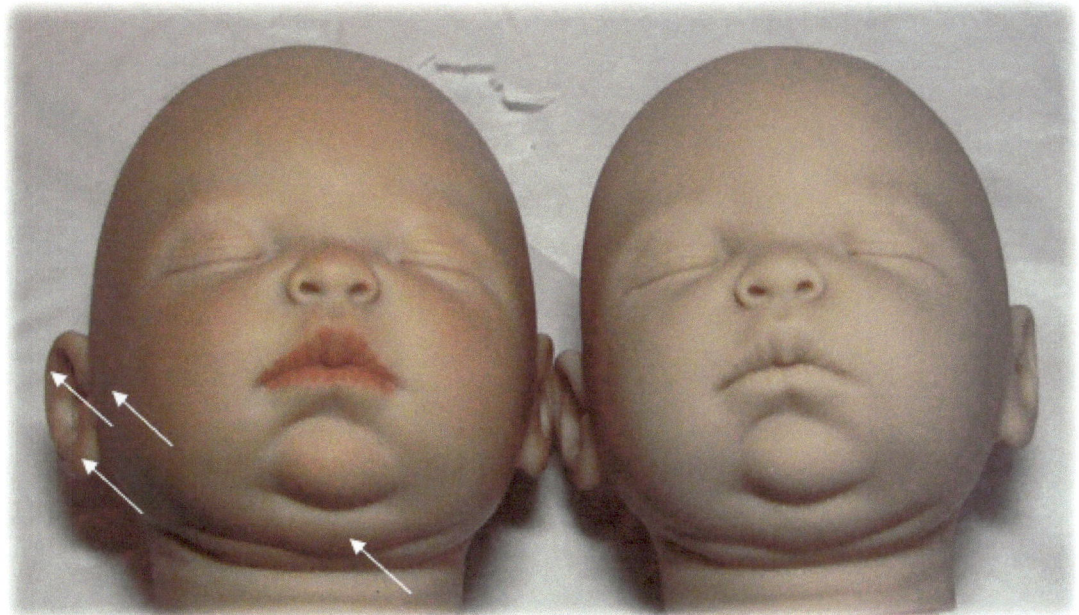

As shown in this picture, I have used the soft rounded tip to apply additional rose color to the outside edges of the ears, the ear lobes and a tad more color in front of the ear space on the cheeks. You may also consider adding this color to highlight the chubby areas between the creases of the neck and chin.

Viewing the before and after samples above, you can see that I have added some soft brown shading on the lips, and external nose folds, as well as inside the nostrils too. Using the pointed tip makeup sponge applicator, you can blend in the colors well inside the nostrils.

Overall, I believe we have done the facial features well, therefore now is the time for the final "heat set" session.

Peaches & Creams Complexions

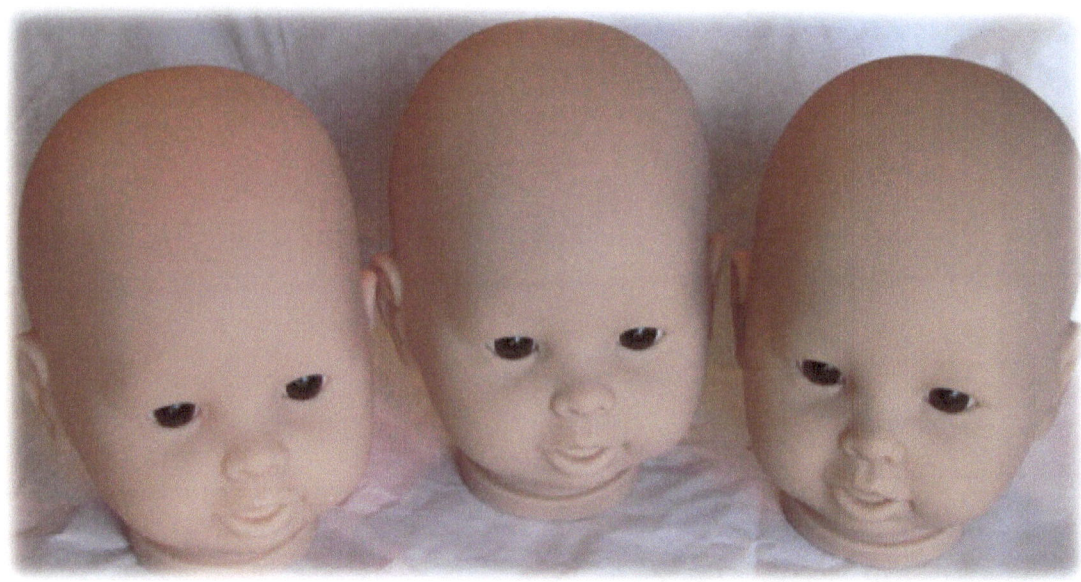

Asian American Sample

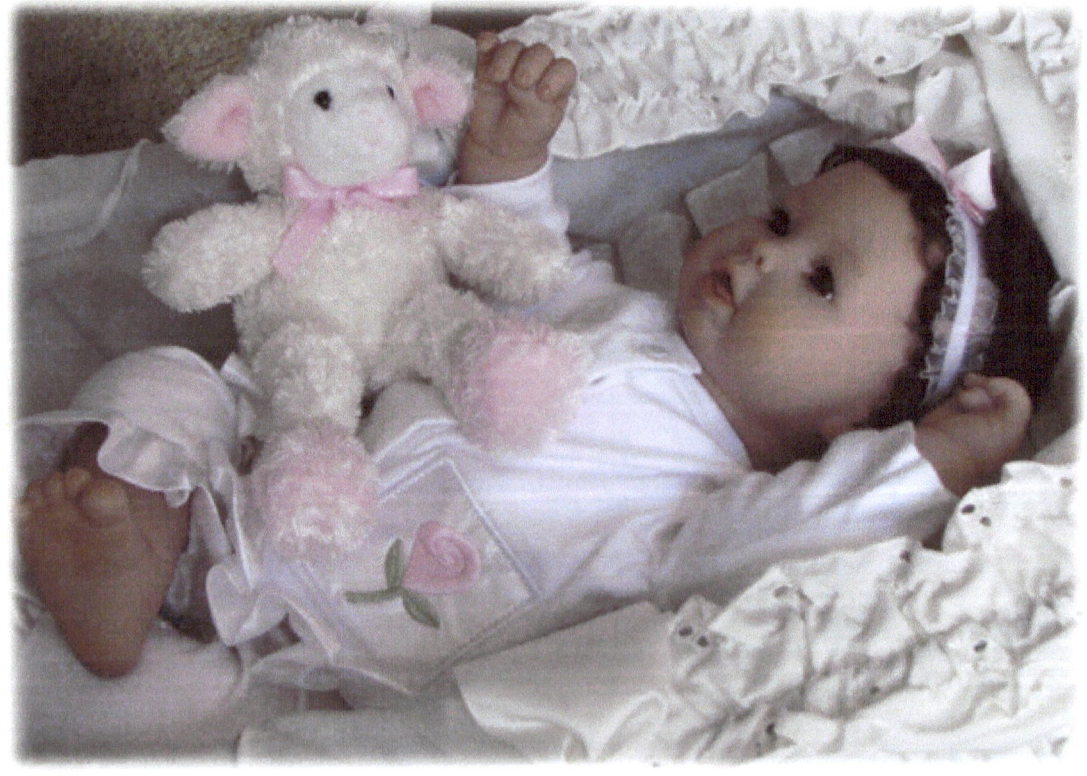

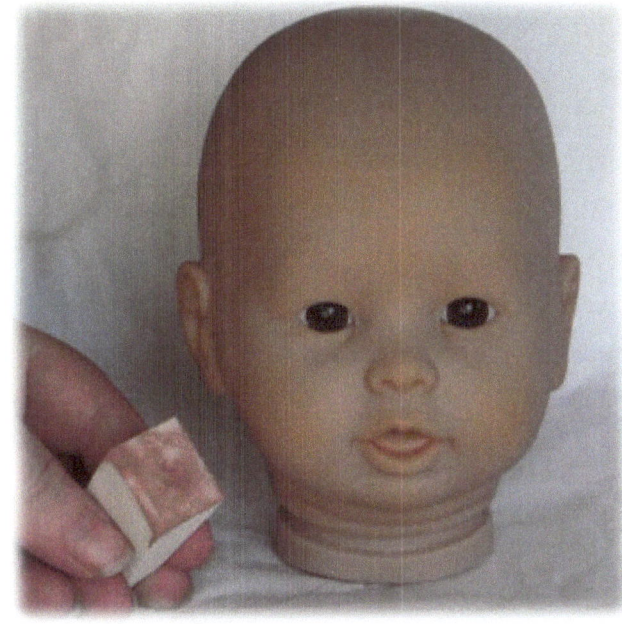

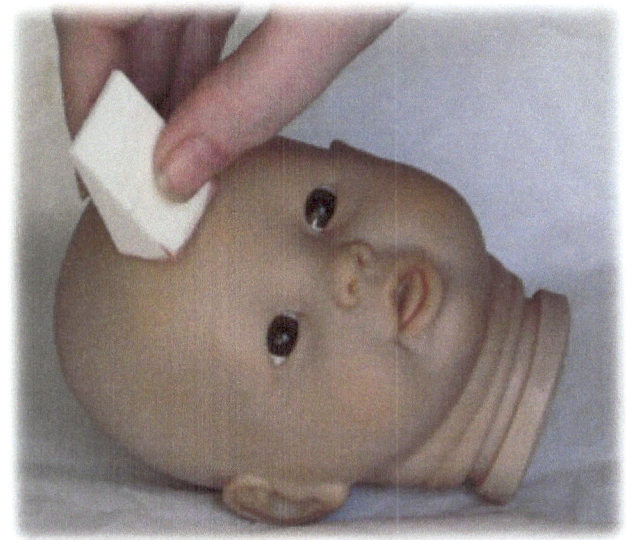

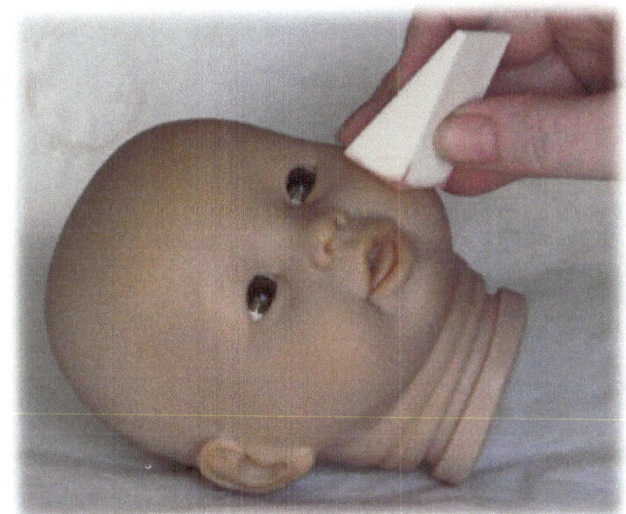

On this light Asian doll kit, I'm using a different Peaches and Cream complexion technique.

The picture at upper left shows the completed peaches and cream doll head; let's mention just some of the techniques used.

On this Asian doll kit, I have shifted my application method to the triangle makeup sponge.

However I'll still use the make-up sponge applicator tip for any smaller detailed areas, such as the mouth and ears (see next page).

My first layer used is an all encompassing layer, ie. I have applied the yellow/white layer all over then head. Then I follow this up with a second layer, where I've added in the yellow umber coloring.

On my third coloring layer I move to use the triangle makeup sponge with just a hint of the apricot coloring (shown at right). I've used my make up sponge tip applicator to place the color directly on the center of the sponge; then I applied the coloring to the forehead, and nose.

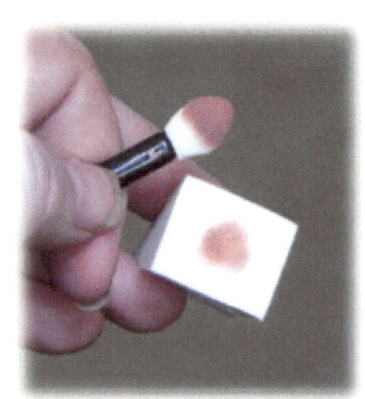

When using the makeup sponge tip applicators, I will use one for color application and another for thinner application in case I need to thin out some areas of heavily applied paint.

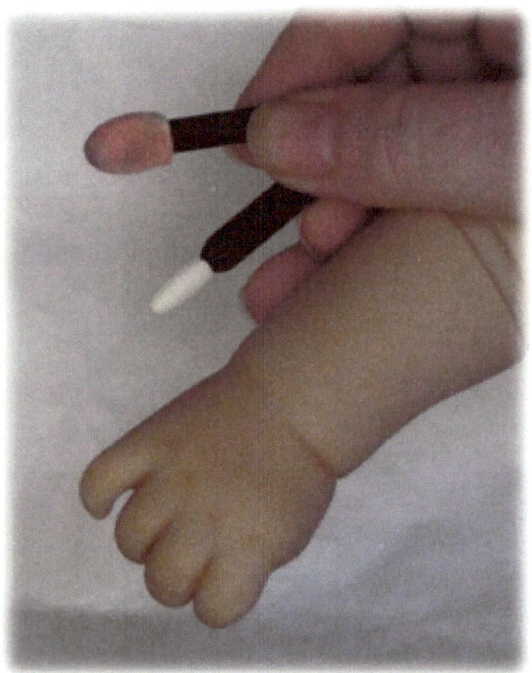

On areas such as the hand, I will use the thin tip applicator for small areas, such as the knuckles, or I may use a thin brush, and follow it up with a few pounces of my sponge to soften up the look on the vinyl so it doesn't look like I just painted it.

As shown in this picture, I'm using the soft rounded tip to apply additional natural color to the outside edges of the ears, the ear lobes and a tad more color in front of the ear space on the cheeks.

You may also consider adding this color to highlight the chubby areas between the creases of the neck and chin.

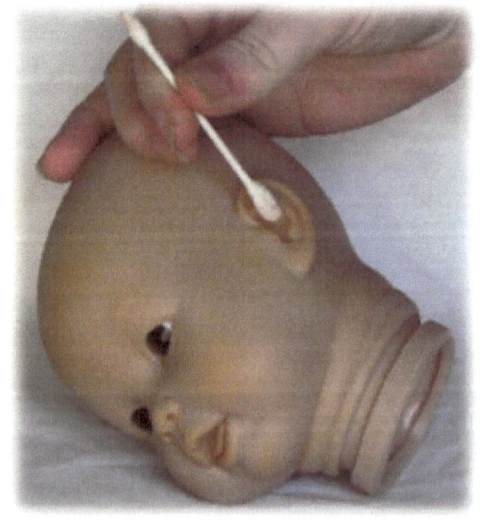

When working the lips and the mouth, I will use a thin lip liner brush to

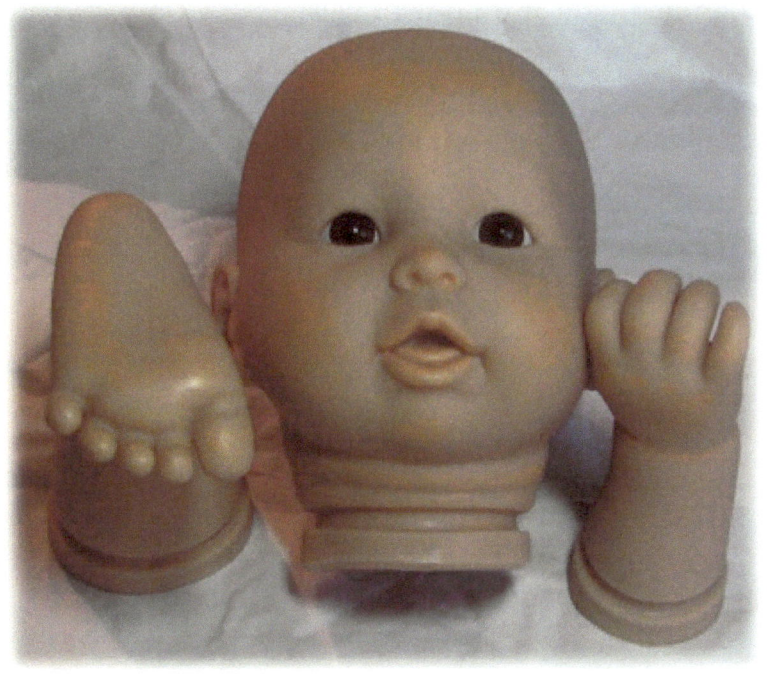

pick up some of the brown color and mix it in my rose/red/burgundy mixture of paint. Then paint in the creases and crevices, as well as the lip lines. I do not bake it yet, as I need to soften the look. So again I will use the makeup sponge tip applicators to dab over the lines to soften it up.

The pouncing effect will blend in the colors nicely. Depending on how much dabbing you do will determine the amount of paint that remains to stain the lips and mouth section.

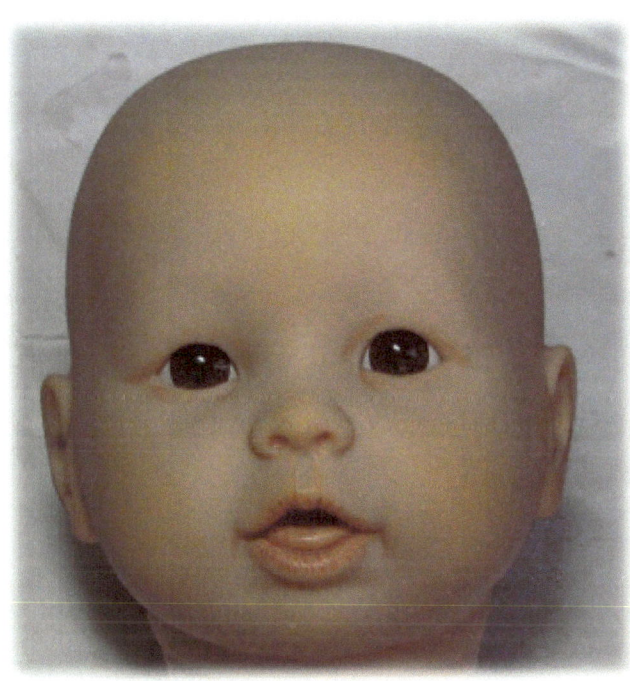

It is now time to do another "heat set" session in the oven; then more detail work will be done.

After the light brown color is applied and set, I come back with my liner brush which I had used for the detailing work, and add in some additional brown into the corners, the middle lower lip

and at the two arches of the upper lip. I'll then pick up some of my soft brown color and lighten it up with Flesh 08 and mix in a little more thinner. Then I'll grab it on a rounded makeup application sponge tip and apply some lighter shading on the soft portions of the lips and blend in the color for highlights. I can use additional lighter colors for highlights or darker shades for lowlights if I wish.

Once I'm happy with the face, I will move to the hands and feet with the same soft brown color for additional details.

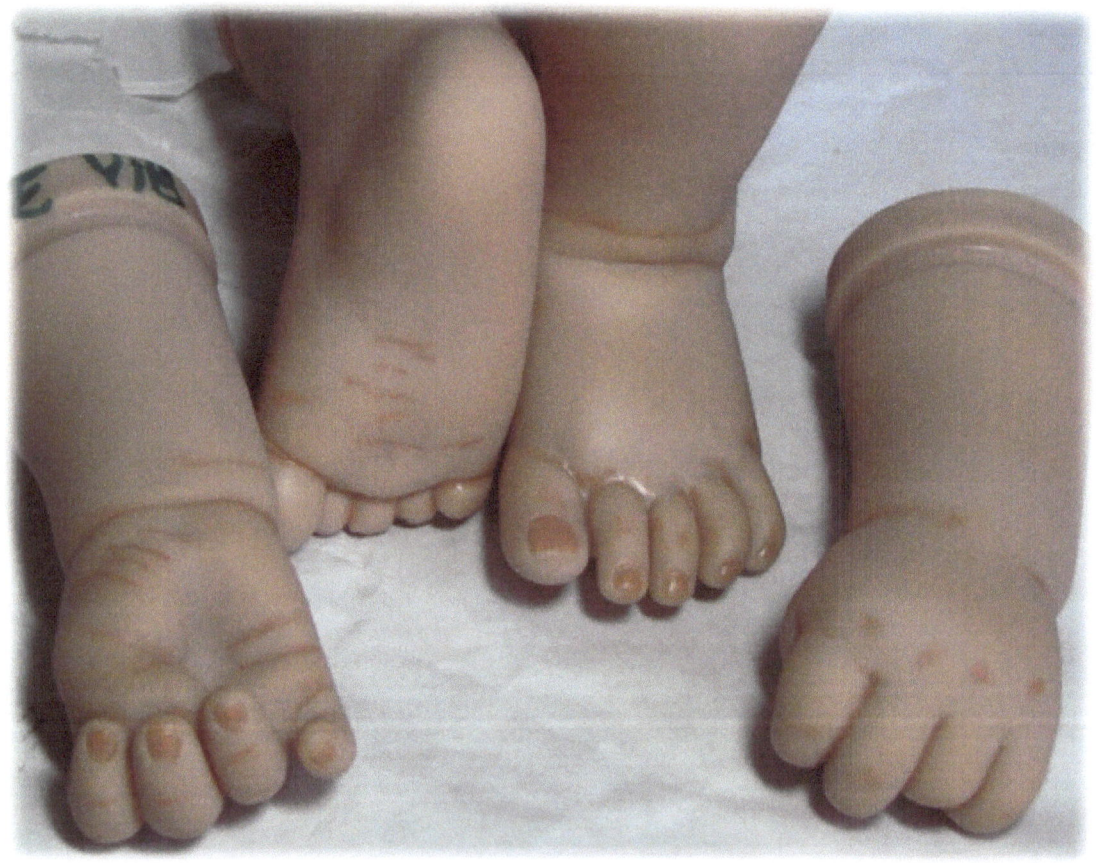

For the detailing work on the arms, legs, feet and hands, I will use the soft brown colors (you could go darker if you wish).

Using my liner brush again, I gather up the color, gently wipe across my paper toweling to remove any excess and apply to each line or crevice on the limbs. Following that, I use the rose/apricot color with my soft makeup sponge

to highlight the chubby sections between the crevices and folds, as well as hit the knees, heels, fingers, back of the hands, and any other areas of interest.

If the colors look to sharp, I will dab on with my makeup sponge with a dampened amount of thinner to soften the features before our next "heat set".

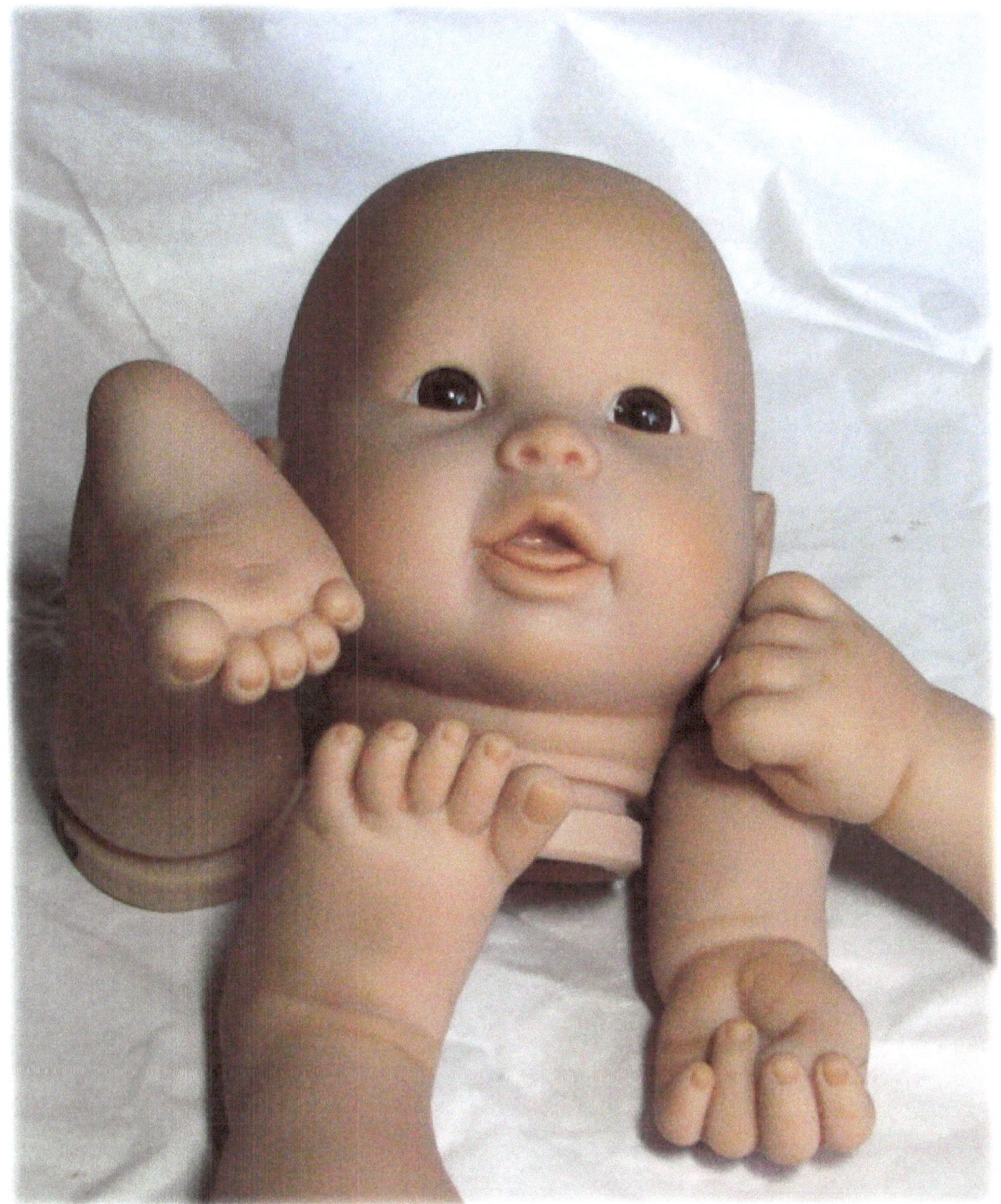

She is almost completed with her new look. I just need a bit of work on her lips before I do a final "heat set" session. I have to admit, I will wait until I

her hair is rooted before I put on the final finishing touches, as my final blush color may depend on her hair color. You can use all the GHSP products for your doll kit color work; however I do my final accents, as well as glossing of the lips and nails as a finishing touch to my newborns (see the Finishing Touches section for more).

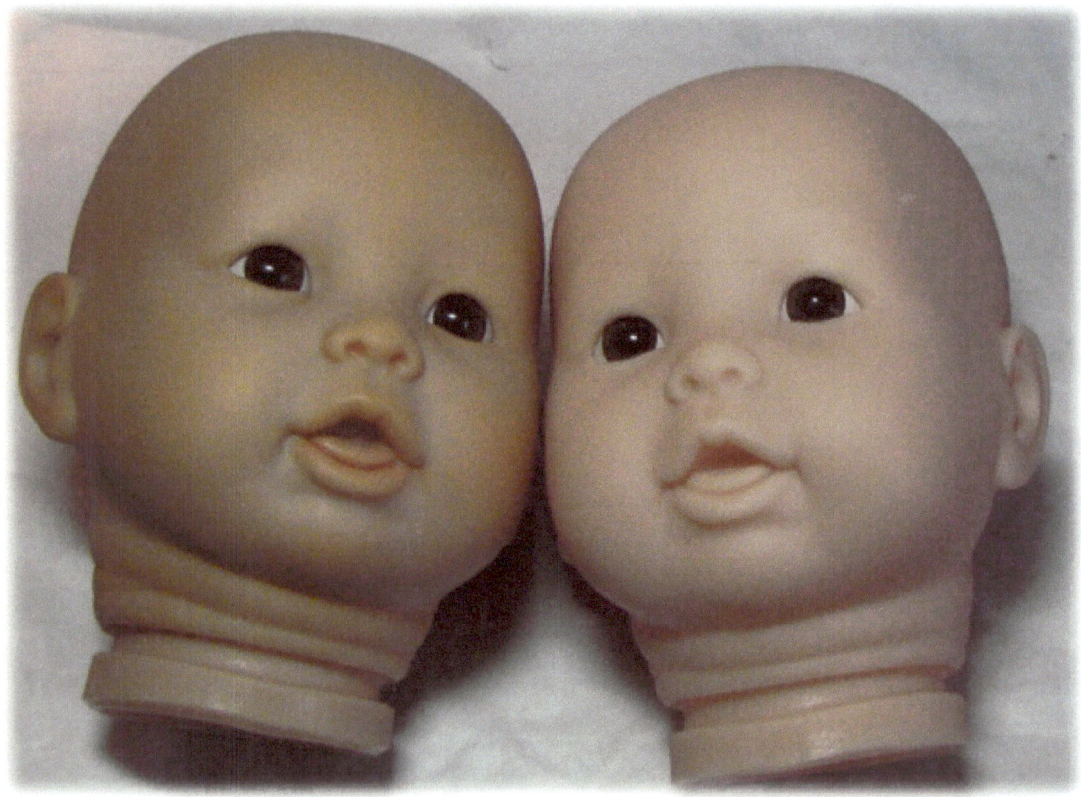

In this picture, you can see better the overall skin tone application as compared to the original blank doll kit head. Even without the hair, eyelashes and brows, she is looking pretty darn good.

You may want to apply the color sealant or the Genesis Heat Set Matte Varnish finish to the face and head prior to the application of your hand rooted hair to the head, or hand applied wig; As once you have hair on the doll, you can create situations where the extra lose strands of hair will get stuck in the sealant and be permanently applied to the cheek, ear, forehead, or other areas where it really just doesn't belong.

CAUTION: You do not want to have to "heat set" your wig or hand rooted in hair. If this has to be done, please apply a damp cloth over the hair so that it doesn't dry out or catch on fire. Keep your doll parts and head at least 5 inches away from any heating elements.

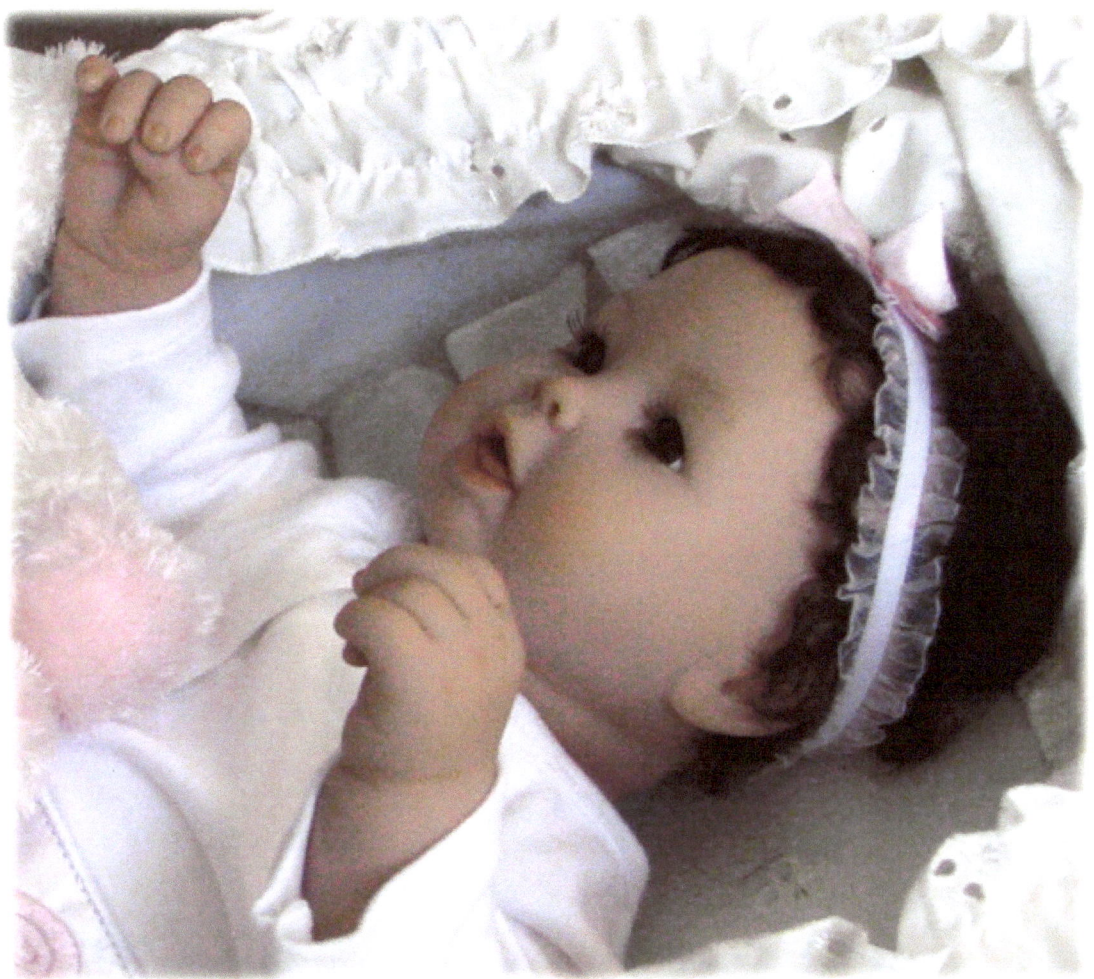

Minueta has upper and lower lashes hand applied and sealed in with Aleene's paper glaze (more on this in the Accents section). She also has very fine micro hand rooted in eye lashes.

Minueta currently has on wiglet portions which are attached to her headband. Later on I will hand root in these snipped sections directly onto her vinyl head.

Peaches & Creams Complexions

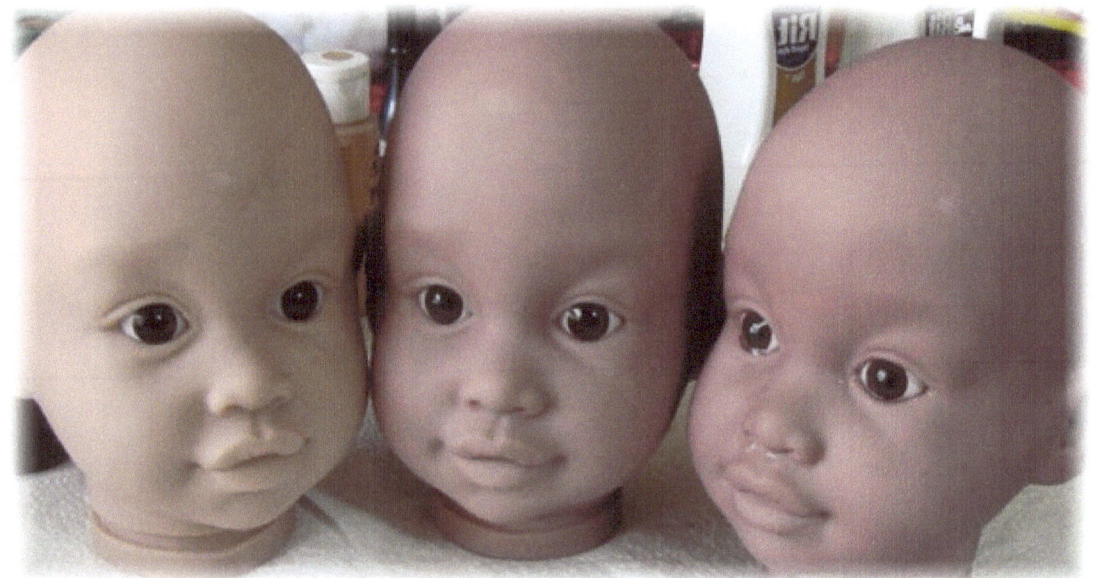

African American Sample

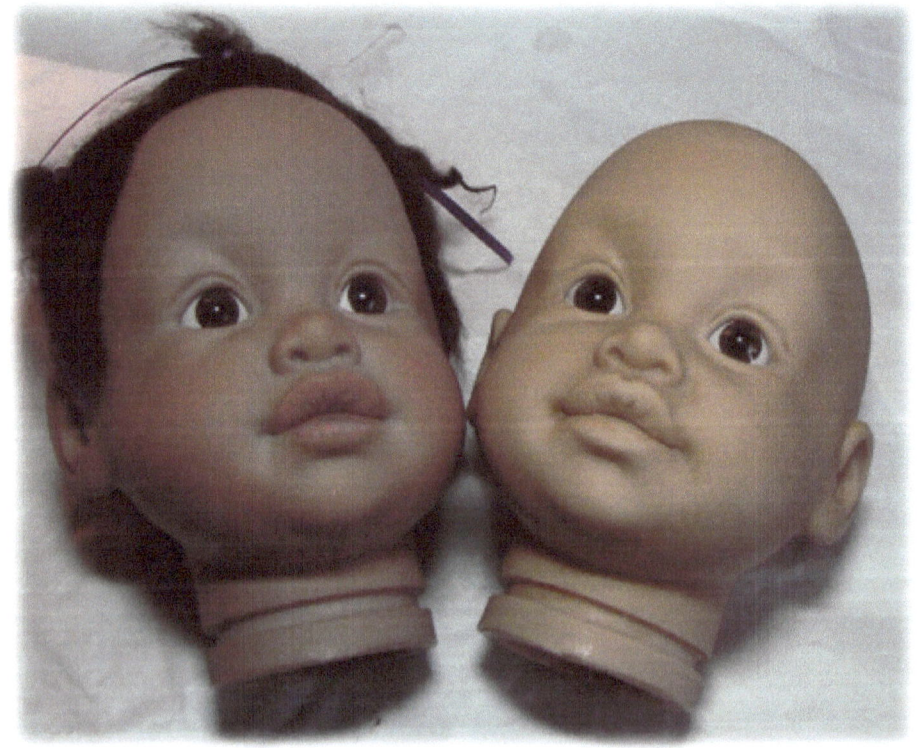

Our African American Peaches and Cream sample will be our girl; I've named her Tiesha, and she will be a twin sister of her brother Ty. Ty will be completed using the 6 step layering technique in Part 2 of the Book Series.

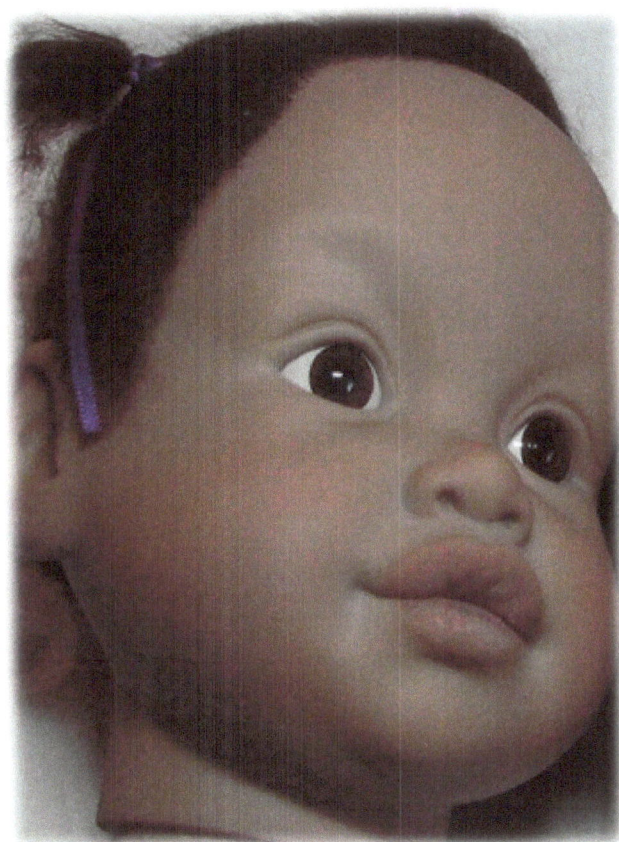

So let's talk a bit about Tiesha's Peaches and Cream complexion layers.

One thing I did differently with Tiesha, is that I rooted in her hair before I applied her facial coloring. I don't recommend it, but it is an advanced artist option.

The first layer of coloring I did on Tiesha's face was a mixture of Flesh 03 and Flesh 05, thinned out with about 6 to 8 parts thinner.

I used the fan brush to apply the color mixture all over the face; then I used my blending cloth to blend in the initial tonal layer.

Once that was accomplished, I went immediately to the rose coloring and applied the paint to a triangle makeup sponge.

By applying the paint in this way, allows you to not have any square sponge edge marks showing, as all the coloring is in the middle of the sponge.

The blushing color was applied to the forehead, nose, cheeks and fleshy areas of the neck, and finally to the external ear sections.

Then a "heat set" session was completed.

I followed this up by applying a second layer of the rose color to the lips. Then added in a bit more brown coloring; and applied a second layer to the lips.

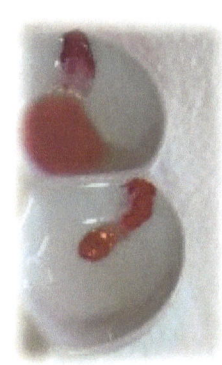

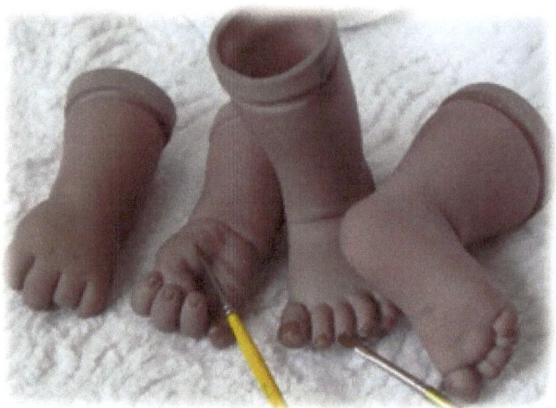

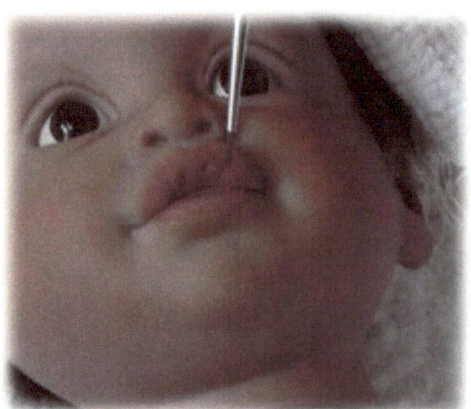

Then using this same soft brown/rose coloring, I added in the detailing of the creases and crevices of the eyelids, inside the ears, inside the nostrils exterial of the nose and lip lines of the mouth. I used this same brown detail coloring on the hands and feet.

Ty (in blue) is featured in Part 2 of the 2 Part series book **Excellence in Reborn Artistry**™ *Learn to Paint with Genesis Heat Set Paints: Newborn Skin Layering.*

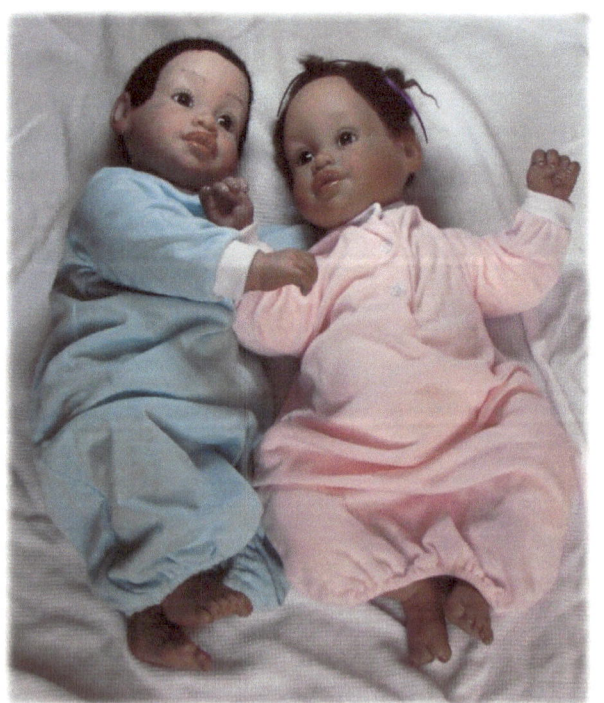

Excellence in Reborn Artistry™
Section 3 – Accents, Body Art & More…

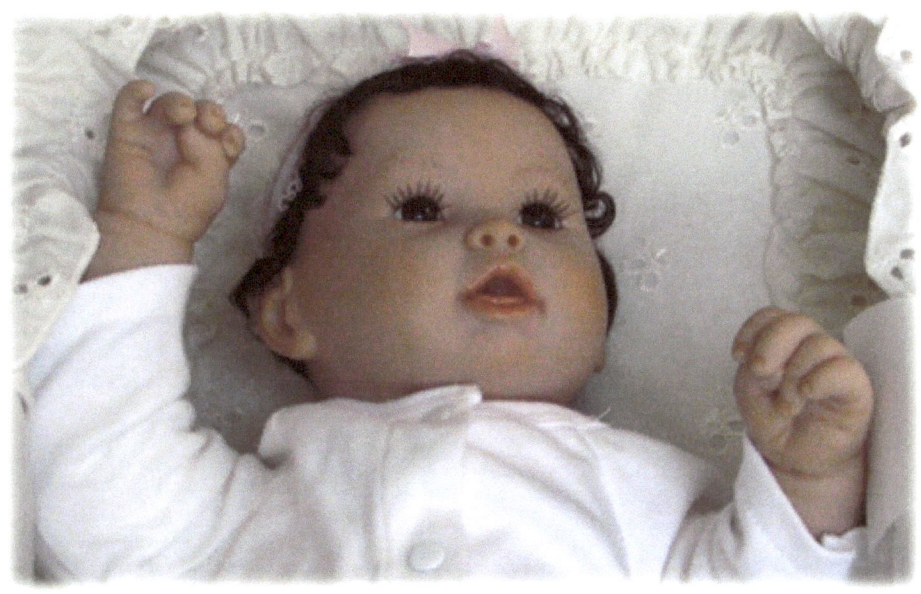

Body Accents

We have provided in the various sections bits and pieces of information regarding various accents for creases, crevices, body folds and high lights. We

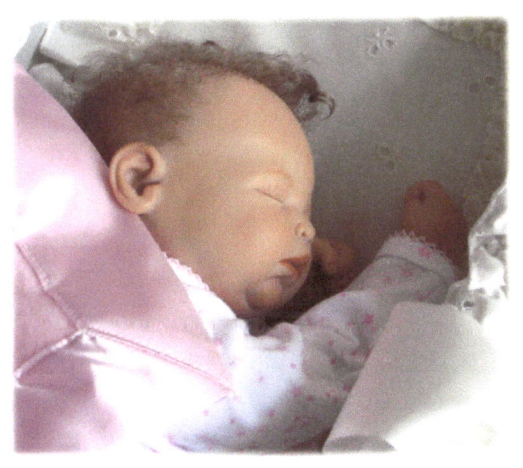

wish your reborns to have their skin folds meticulously blended with hand applied colors in your choice of specially blended pigments. Each one of the baby features should be custom applied, highlighted, and shaded to give your baby a realistic and healthy glow.

You can use oil and paint brushes, q-tips, and or makeup sponges to help you apply the colors together for blushing with sponges, soft brushes, or your blending cloth.

When in doubt, use less blush color, and then wait to see the results in a few days. You do not want to over-blush, you simply want to accentuate the baby features in the crevices, wrinkles and folds; as well as the hills and valleys.

Areas of Interest when Blushing...

ARMS... Upper shoulder, elbow, wrist, inside mountains of the palms, each and every knuckle, finger tips, finger nails (more on that in the manicure section)

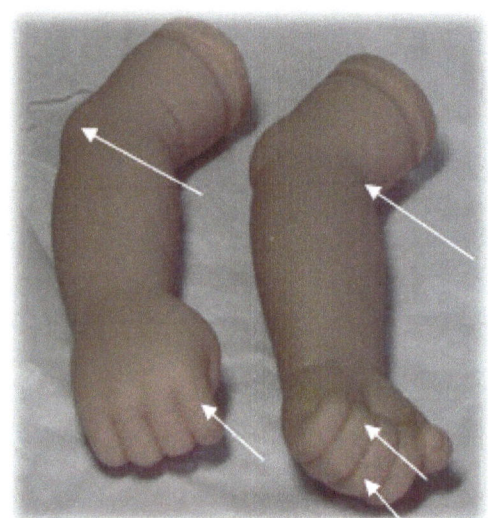

LEGS... Upper thigh, knees, under knees, ankles

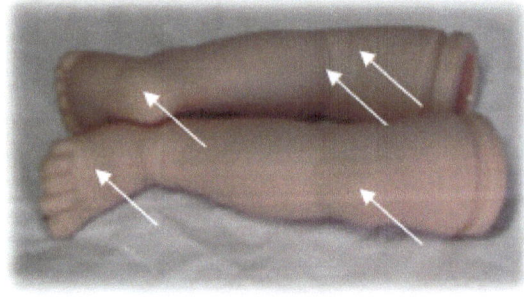

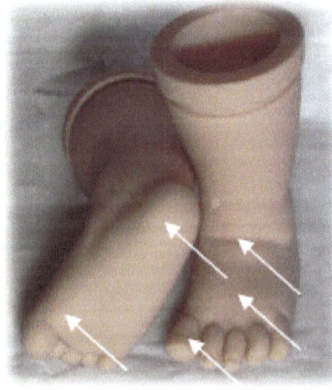

FEET... Folds by the heal, under foot soft pad, toes, toe joints, toe nails

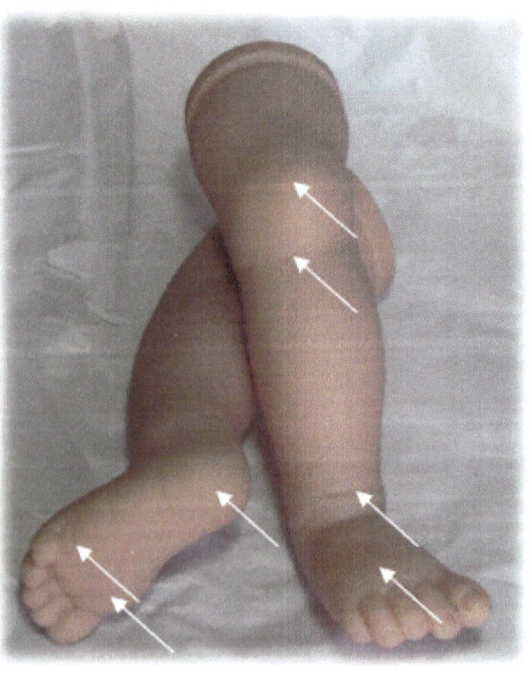

HEAD…

Nose: both inside and outside for shading; mouth, mouth creases, tongue and mouth arch inside, if open mouth baby; chin, cheeks, under eyes, eye lids, eye creases, eye brows, forehead, front area of ear, ear lobes, behind ears, inside ears, outer upper edge of ear; neck, back of neck folds; and fatty portions of folds.

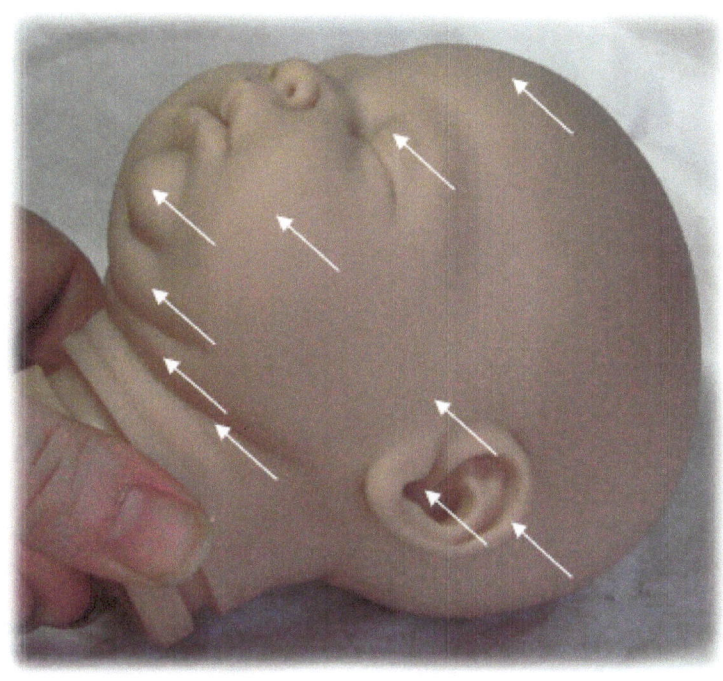

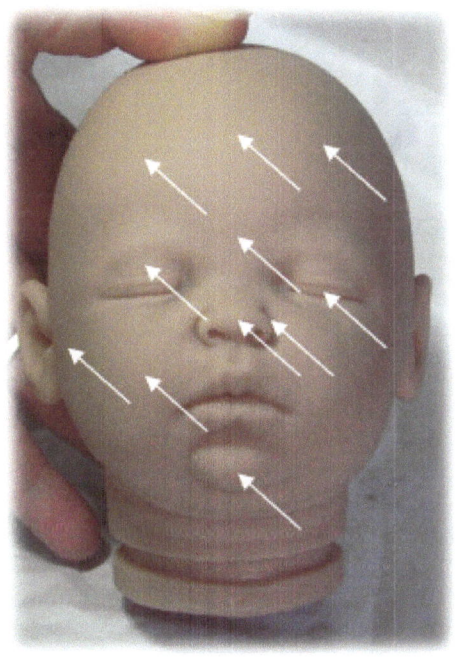
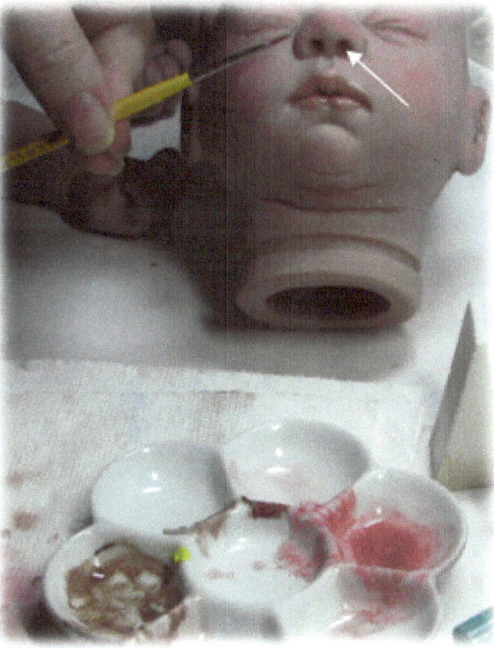

Picture at right shows the darker brown color to use after the soft brown, when you want more emphasis in your shading.

Shown on this picture is a better shot of the nostrils and open mouth of this Asian doll sculpt. Start the highlights of the lips and inside the mouth using a liner brush by adding a bit of brown to your final red/rose/mauve accent skin tone color mixture.

You can use a glossy or semi glossy sealant for both inside the mouth, on the lips, inside the nostrils and around the edges of the eyes; this adds a bit of moisture look and feel to your collectible.

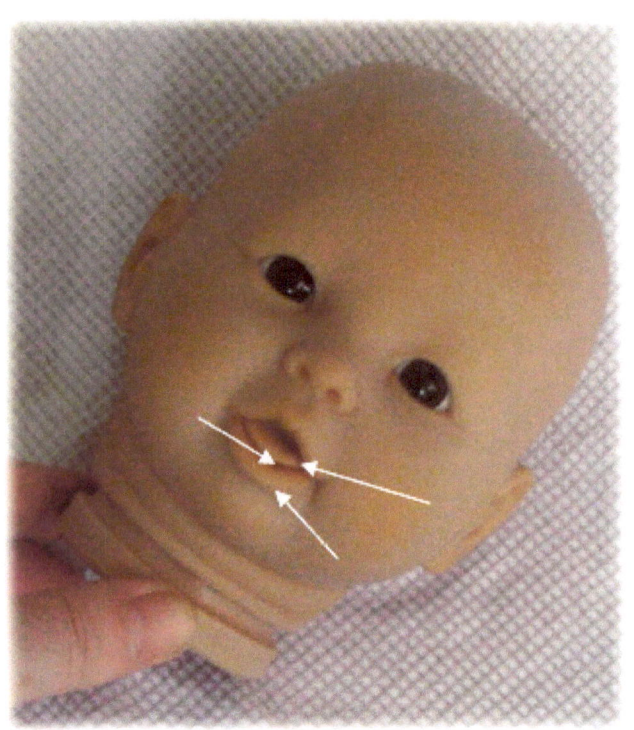

Just as we have discussed previously, the accent points are both in the creases and crevices, as well as the fatty portion of the folds of the skins.

When doing the coloring techniques, it can be a little more difficult to access these areas in the hands and feet, due to the size of the sponges and size of the limbs. Therefore many artists will switch from large sponges to smaller mottling brushes (like the Maxine Mop brush) and / or thin liner brushes to do this detailed work.

Some artists will use the pink shades to accent the creases and crevices, while other artists will use more brown shades for this work.

For me, it depends on the doll sculpt and the sex of the reborn. I emphasize with the darker brown colors for boys and lighter pink colors for girls. You can also mix the reds with the browns for a unique coloring accent.

There is no right or wrong answer, it is just the techniques that have been chosen, and the look you wish to achieve.

It is great fun to see the colors bring your reborn to life as you go through each step in the coloring application process. Once the colors are applied; then continue to the next step of sealing the lips and end with a good manicure of the nails. You can apply color to the nail beds which are slightly lighter or slightly

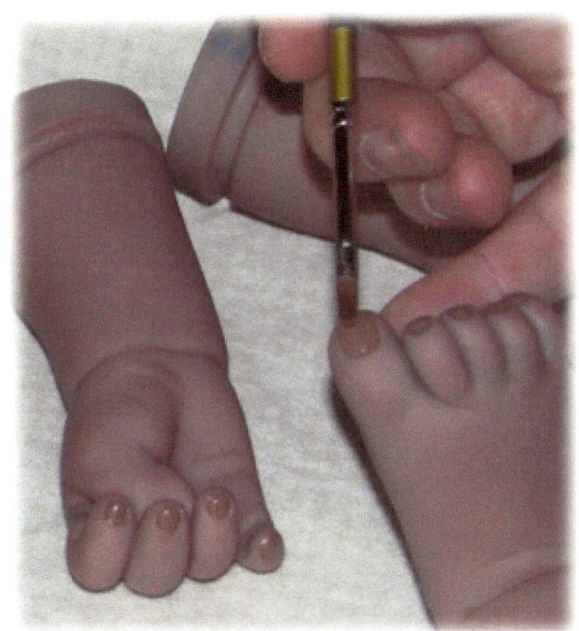

darker than the skin tone color you've selected for your reborn. If you look at my nails above, you can see both darker and lighter areas, so I believe either one will work wonderfully on our dolls.

For the nails of your girl dolls, you may wish to provide a French tip look to the nails and cuticles with Titanium white mixed with a hint of your favorite skin tone colored paint. Apply with a really fine liner brush. I've used white shown below on the AA reborn, so you can see it better in the picture.

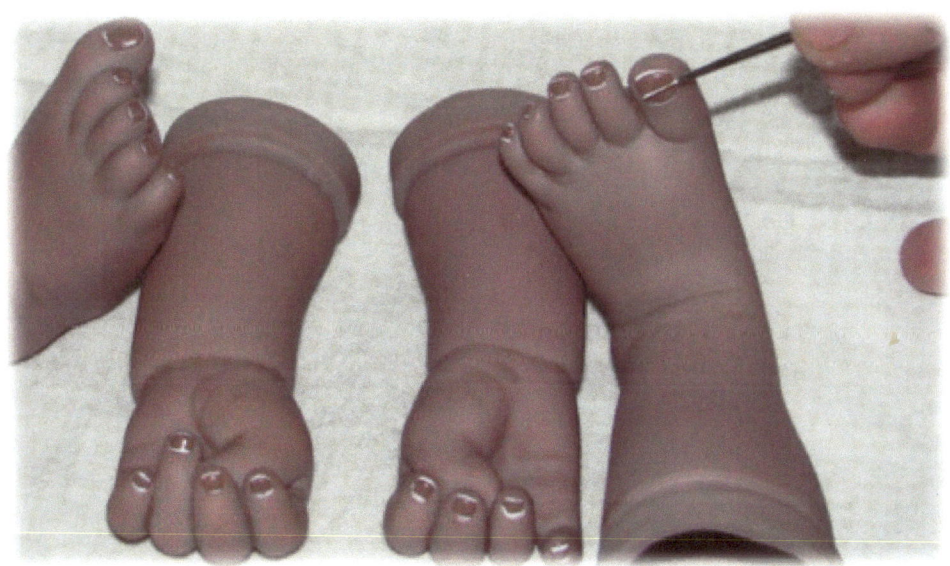

Facial Accents

Eye Lashes

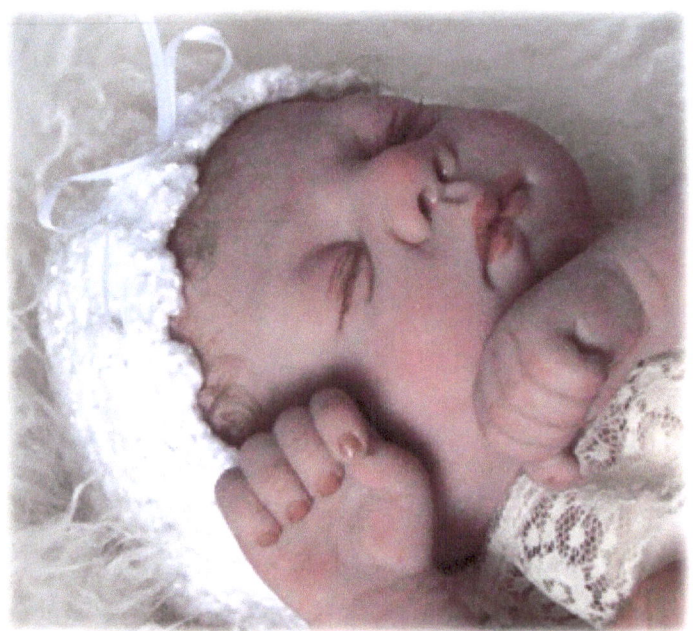

Eyelashes can be applied, or hand rooted into the vinyl. It's easy to hand root the lashes for a sleeping baby reborn (see picture at left); however much more difficult for an opened eyed doll as the doll's eye is normally in place when you attempt to root.

So many reborn hobbyists will just hand apply eye lashes on dolls with open eyes. As shown below, take the lashes that you have purchased, and line them up against the eye opening. Then snip them to the correct length.

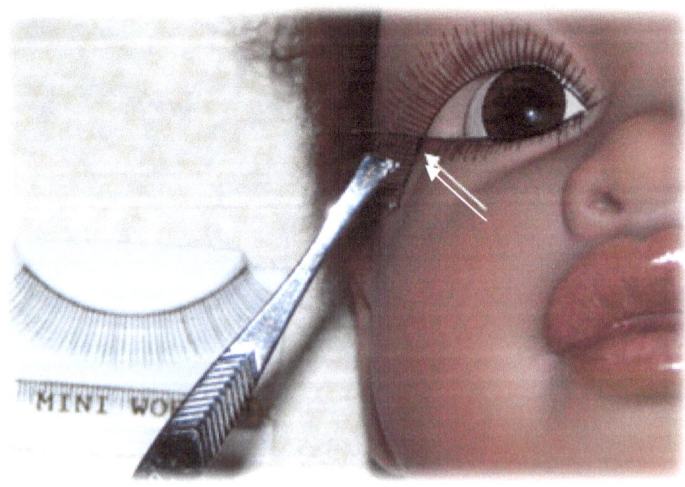

Position the lashes onto the crease between the eye and the vinyl, then glue in place.

I normally use Aleene's Clear Gel Tacky glue for attaching doll eyelashes most of the time. It is an excellent adhesive and allows

you plenty of time to get the lashes positioned correctly. It is also easy clean up if you make a mistake.

However, another more advance option is to use Aleene's Paper Glaze to help set the lashes permanently on the face. *Yes, it looks a little ghoulish ☺ until it dries.*

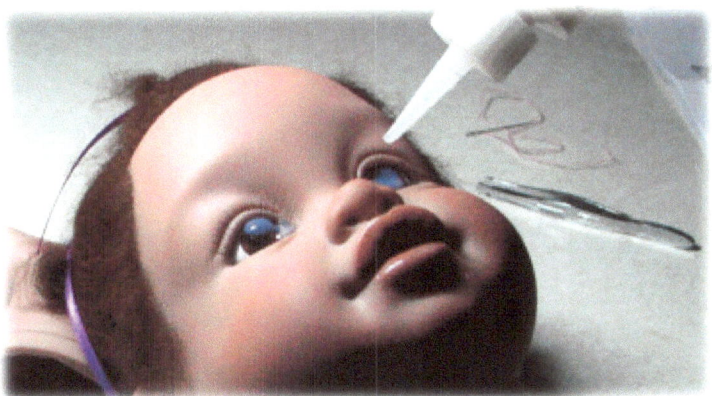

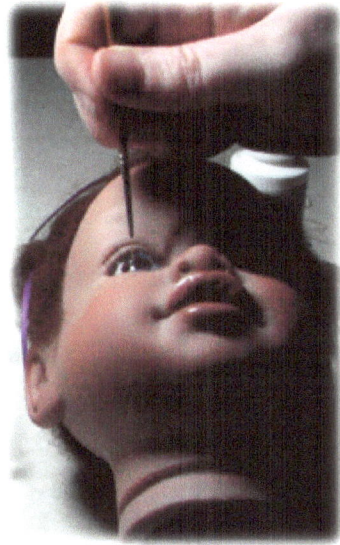
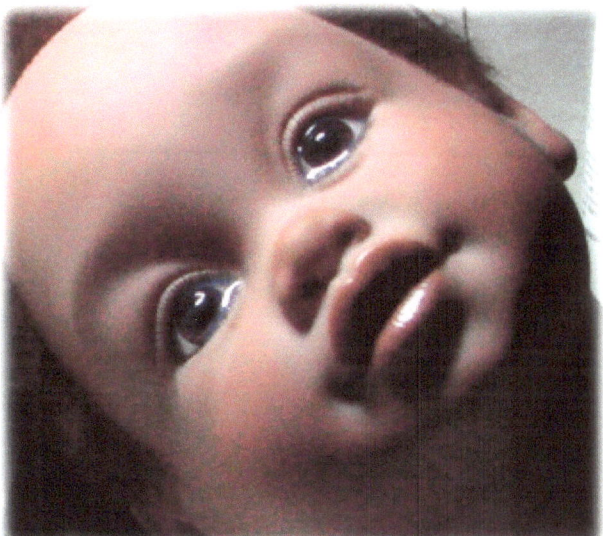

Drop a bit of Glaze on the eyes; then use a brush to move the glaze all over and around the eyes, and into the lash crevice. Allow to dry for 1 to 2 days before you move the head. Watch it for a few minutes… If you find you have too much glaze in the corners as it settles, you will need to remove some of the glaze from the corners.

CAUTION: Do not use any form of super glue on your eyes. Once they touch the surface, they will permanently dull the eyes appearance.

Eye Brows

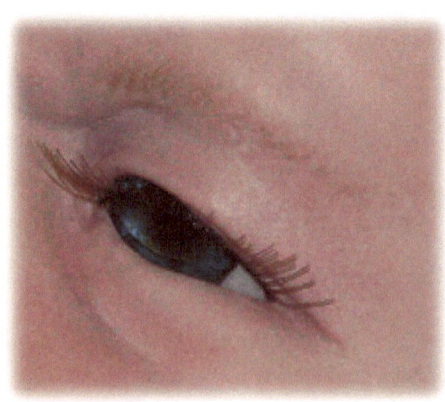

Painting on barely there eyelashes is an art form in itself. Many hours are normally needed in order to perfect the technique. The trick is to have a very thin eye liner brush with a minimal number of hairs.

One artist I know uses a brush with only 4 hairs when painting on eye lashes.

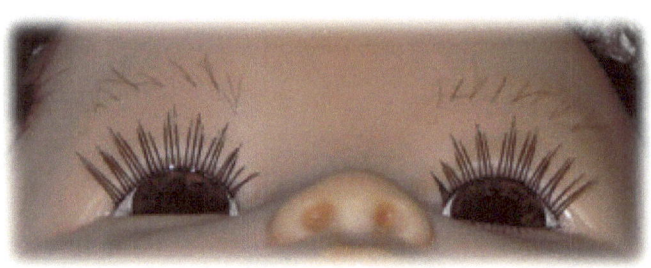

When rooting in eye brows, the most realistic results are achieved using individually hand rooted strands into the vinyl using a size 40 or 42 felting needle. Warm up the head first, which makes insertion easier, the holes less noticeable.

Wonderful Newborn Baby Smells

To add a lifelike baby's touch to your reborn, just sprinkle in a little Johnson's Baby Powder onto the baby's diaper or sprinkle onto the undergarments. Rub it in a little so that it doesn't shake out.

You can also sprinkle in a little into the stuffing when you are stuffing and weighting the new soft body. Shown here is our sleeping beauty with the doll kit body filled with polyester fiber fill and weighting beads. When filling the body, remember the more weight you use in the limbs, the less like the doll will be able to hold his or her poses. Joints are great for posing, but if the limbs are too heavy, they will still drop or fall down.

Satin Sealants & UV Protection

As with many of the painting methods for reborning, it is highly recommended that you use a surface sealer once you are finished with your baby to protect and preserve your reborn creation. GHSP has the Heat Set Permanent Matte Varnish product to use.

When using GHSP Matte Varnish, work or mix it up well; place the amount you are going to use on a larger porcelain tray, which will allow you a bigger area to work the medium into a thinner consistency (you can apply a bit of thinner if you wish).

Then use your makeup sponge applicator and pounce all over the vinyl you wish to have the GHSP Matte Varnish finish applied.

I find it is better to do two thin layers and "heat set" in between each layer, versus one thick layer with one "heat set" session. Sometimes when the paints and varnish are too thick, they may not dry appropriately and you can get the spotty cloudy or chalky affect.

If you decide to do this layer of protection, make sure you apply it <u>prior to</u> the application any of the glossy detailed work.

Glossy Lips, Sleepy Eyes & Baby tears

To create moist realistic looking tears, or add wetness to lips and open eyes or weepiness to sleeping eyes, Aleene's Paper Glaze is a fun product to use.

Glossy Lips: First I use my lip liner brush and apply to the lips all over. Then let dry for 24 hours. Then I take my eye brow liner brush that has only 1 or 2 strands and apply again only to the lip areas to create a bit of depth. Try it. You will love the affect.

CreationsByJeannine™
Excellence in Reborn Artistry™ Books, eBooks, & CDs
Instructional, Informative, Guidelines, Tips & Techniques

Always available at www.lulu.com/jeannine

Back — Front
300 Full Color Pictures

Learn the Art… Soft Cover Books & eBooks Available. **Create Breathtaking Reborn Baby Dolls.** You take a simple vinyl doll and transform it to a One-of-a-Kind Heirloom Collectible. This book provides you the knowledge to Reborn Vinyl Dolls and Dolls By Berenguer Reborns and includes an instruction manual for Beginners and Intermediate Reborn Artists. It is a great book for Artists-in-training, as it has been used by instructors around the world to teach this wonderful art form.

The book includes 14 overview sections: Supplies, Disassembly, Bathing, Blushing, Soft Body, Facial Features, Subtle Veining, Magnets, Pacifiers, Juices, Milk Bottles, Stuffing and Weighting, Baby Fat, Manicures, Heart Boxes, Heat Pouches, Making Umbilical Cords and also has many Life-Like Reborn Samples, Reborning Tips, Techniques and more…

Back — Front
75 Full Color Pictures

Breathtaking Reborns with Realistic Newborn Skin tone… You can take a simple vinyl doll and transform it to a One-of-a-Kind Heirloom Collectible. This book features techniques for Vinyl Reborns and is an instruction Manual for Advanced Beginners and Intermediate Reborn Artists. It covers the technique to reborn the most realistic preemie and infant with just born skin tone techniques. The book includes: Supply basics, Layering Techniques for Newborn Skin, Just Born Skin, and Days Old Skin tones. External and Internal veining discussion is also included. Our most popular Case Study for two years running…

Back — Front
175 Full Color Pictures

More On Mottling… This book continues the discussion on mottling skin reborn techniques for Vinyl Reborns and is an instruction manual for Advanced Beginners, Intermediate Reborn Artists, and Hobbyists. It covers the technique to reborn the most realistic preemies and infants with just born skin tone techniques. The book includes: Supply basics, Recap of the Layering Techniques for Newborn Skin, Discussion on Sponges and their uses, Step-by-step instructions to create several custom OOAK tools for your own reborning needs. It also includes interesting application Variations for veins, arteries, capillaries and other features.

Back — Front
Full Color Pictures

ALL 6: SOFT BODY PATTERNS. Reborn Vinyl and Silicon Vinyl Dolls 32 sizes / Patterns / Configurations / Style Combinations
Stable Soft Body Patterns – Fits Most Berenguer Dolls 1: Non-Jointed Soft Body Full Limbs – **10 sizes** 2: Jointed Soft Body Full Limbs – **9 sizes** 3: Oval Soft body ¼ Partial Limbs-4 popular sizes Oval Soft Body Patterns – Fits Many Silicon-Vinyl Dolls 4: Artist Dolls like Baby Emily & Alex – 4 sizes 5: Artist Dolls like Sheila Michael – 4 sizes 6: Jointed Oval Soft body Pattern Full Limbs- 4 popular sizes combinations

Find all our Books, eBooks, and Movies on CD at www.lulu.com/jeannine

Back | Front
85 Full Color Pictures

Beautiful Heirloom Reborn Babies with Realistic Hair... This book will take you through the detailed steps involved in creating a reborn with Realistic Hand Rooted Hair. It features the hair rooting process for several dolls for you to see the steps involved with Mohair and Human Hair Rooting and Techniques. From the basic Hand-Rooting to Mini-Rooting, Micro-Rooting and the new Ultra-Micro technique. These techniques can be used on Vinyl and Silicon-Vinyl dolls. Includes supplies list, Step by Step Instructions, and Tips & Techniques. A very popular Case Study #6 in the Excellence in Reborn Artistry™ Series.
New MOVIE on CD available to compliment this book.

Back | Front
750 Full Color Pictures

Excellence in Reborn Artistry™ MASTER COLLECTION - The BEST OF SERIES... This book is updated every few years to include the most popular Books in the series. Instructional and Informative with guidelines, tips & new techniques... Always includes the most popular book Learn the Art (the Basic & Intermediate instruction books), as well as 4 of the most popular Case Studies which provides in detail the many facets of Reborning. This book would not be complete without our most popular 6 Soft Body Pattern Booklets with Step by Step instructions and full color pictures. **Our MOVIES on CD compliments this Best of Series Book nicely.** 12 Books/Booklets.

Back Cover | Front Cover
300 Full Color Pictures

Collector's Edition Book (Parts 1 & 2, plus Bonus Materials). Learn to use Paint using Genesis Heat Set Paints on Newborns, Toddlers and Reborn Dolls. The perfection of Peaches and Creams Complexion, along with Newborn Skin Layering Techniques! PLUS bonus materials you will not find in Books 1 or 2 of the series. Includes: Internal "color wash" application techniques; External color application methods; AND Bonus Section on liquid dye methods. Our featured Secrist dolls in this book are Zoe, Ming & Starling; PLUS in addition Taffy - a wonderful example of medium skin tone newborn layering techniques. This full art book also touches on Veining, Facial Accents and Body Art options; bonus materials include wig application. Wonderful techniques that can also be used for acrylics, oils, gouache and more... **Get the Companion Movies on CD.**

Back Cover | Front Cover
100 Full Color Pictures

Learn to Paint PART 1 of 2: Peaches and Creams Complexions. Learn to use Genesis Heat Set Paints to create the most beautiful Collectible & Heirloom "One of a Kind" Dolls. This art book provides the following valuable information for the beginner: Create your base skin tone from the inside with Internal "color wash" application techniques; See the Peaches and Cream Complexion techniques come alive on three of the Secrist doll kits: Zoe, Ming & Starling; A wonderful technique for your perfect baby or toddler. Also includes Facial Accents including sleepy eyes and Body Art options; sure to create a heirloom and/or collectible doll. Bring to life, your own Custom Reborn Baby; Isn't it time for A Precious Heirloom Baby of your very own? **Companion Movie on CD available.**

Find all our Books, eBooks, and Movies on CD at www.lulu.com/jeannine

Back Cover — Front Cover
150 Full Color Pictures

Learn to Paint PART 2 of 2: Realistic Newborn Layering Techniques. Can you imagine a baby so perfect, it looks just like it was newborn? If you need light, medium and darker skin tones with a hint of the blotchy effect and a touch of mottling, then this is the book for you. This art book provides the following valuable information for the beginning artist or reborn hobbyist: Create your base skin tone from the outside with external application techniques; See the Newborn and Just born painting techniques shown on three of the Secrist doll kits: Zoe, Ming & Starling; A wonderful technique for newborn baby in your life. Also touches on Veining, Facial Accents including tears and Body Art options; sure to create an heirloom and/or collectible infant doll. Bring to life, your own Custom Reborn; So realistic, your friends will think it is a real newborn baby. **Get the Companion Movie on CD, which compliments this book nicely.**

Back — Front
300 Full Color Pictures

Learn the Most… COLLECTORs EDITION - HARD COVER & Soft Cover BOOKs Available. Finally a place where can you find the most color mediums described in any one book in the Excellence in Reborn Artistry™ series. Learn all the most popular color mediums used in the Reborning and Doll Making Hobby Industry. Paint mediums include: Oils, Acrylics, Pigment Inks, Stencil Cremes, Genesis Heat Set Paints, and even a touch on Gouache. This book includes six large sections: Apply Base Skin Tones; Blushing the Peaches and Cream Complexion; Learn the popular Newborn Skin Layering techniques; Complete your work with Accents and Body Art AND includes Soft Body Doll Kit Patterns from the PatternsByJeannine™ line; sure to create a cuddling collectible doll. Bring to life your own Custom Reborn Baby.
Isn't it time for A Precious Heirloom Baby of your very own?

Disc Cover — Insert Front

NOW MOVIES ON CD…

Excellence in Reborn Artistry™ presents to you… MOVIEs ON CD
Watch and Learn Basic Hair Hand Rooting Techniques; Or how to create a Peaches and Cream Complexion or a Realistic looking Newborn with a skin tone so real, it looks like a real life baby…

In our Hair Rooting movie… Jeannine takes you through an introduction to Hair Rooting Tools, Mohair Types, Basic Doll Vinyl Effects, and Felting Needle Basics while demonstrating several Techniques for creating your realistic baby Collectible & Heirloom "One of a Kind" Doll. This Instructional movie for the beginning artist or Reborn hobbyist will show you in detail how to create the cute little curly Q hair and more…

Disc Cover — Insert Front

In our Learn to Paint movies… you will learn the perfection of the Peaches and Creams Complexion, along with Newborn Skin Layering Techniques! Our featured Secrist dolls in this movie are Zoe, Ming & Starling; PLUS in addition Taffy - a wonderful example of medium skin tone newborn layering techniques. We also touch on Veining, Facial Accents and Body Art options.
Wonderful techniques that can also be used for acrylics, oils, gouache and more…

Disc Cover — Insert Front

Find all our Books, eBooks, and Movies on CD at www.lulu.com/jeannine

www.ingramcontent.com/pod-product-compliance
Lightning Source LLC
Chambersburg PA
CBHW051054180526
45172CB00002B/637